PRINT LIBERATION

THE SCREEN PRINTING PRIMER

by Jamie Dillon & Nick Paparone
with Luren Jenison

NORTH LIGHT BOOKS
Cincinnati, Ohio

www.mycraftivity.com

17 16 15 14 13 9 8 7 6 5

Library of Congress Cataloging-in-Publication Data

Paparone, Nick.
Print liberation : the screen printing primer / by Nick Paparone and Jamie Dillon, with Luren Jenison. -- 1st ed. p. cm.
ISBN-13: 978-1-60061-072-1 (alk. paper)
1. Screen process printing. I. Dillon, Jamie. II. Jenison, Luren. III. Title.
TT273.P36 2008
686.2'316--dc22
2008000822

Distributed in Canada by Fraser Direct
100 Armstrong Avenue
Georgetown, ON, Canada L7G 5S4
Tel: (905) 877-4411

Distributed in the U.K. and Europe by F&W Media International
Brunel House, Newton Abbot, Devon, TQ12 4PU, England
Tel: (+44) 1626 323200, Fax: (+44) 1626 323319
E-mail: postmaster@davidandcharles.co.uk

Distributed in Australia by Capricorn Link
P.O. Box 704, South Windsor, NSW 2756 Australia
Tel: (02) 4577-3555

Editor: Jessica Gordon
In-House Design Coordinator: Wendy Dunning
Production Coordinator: Greg Nock

www.fwmedia.com

Metric Conversion Chart

to convert	to	multiply by
Inches	Centimeters	2.54
Centimeters	Inches	0.4
Feet	Centimeters	30.5
Centimeters	Feet	0.03
Yards	Meters	0.9
Meters	Yards	1.1
Sq. Inches	Sq. Centimeters	6.45
Sq. Centimeters	Sq. Inches	0.16
Sq. Feet	Sq. Meters	0.09
Sq. Meters	Sq. Feet	10.8
Sq. Yards	Sq. Meters	0.8
Sq. Meters	Sq. Yards	1.2
Pounds	Kilograms	0.45
Kilograms	Pounds	2.2
Ounces	Grams	28.3
Grams	Ounces	0.035

Designed by Print Liberation
Step-by-Step Photography by Jeff Stockbridge
Illustrations by Tim Gough

Dedicated to Mom, Dad, Chris Sherman, Rick Beaman,
Kevin Duffy and the Fabric Workshop and Museum

Special thanks to: Virgil Marti, Tim Gough, Jeff Stockbridge, Andrew Jeffrey Wright, Thom Lessner,
Outlaw Print Co., Award Winners, Eva Wylie, Seripop, Paul Coors, Space 1026 and the Fabric Workshop and Museum

CONTENTS

PRINT LIBERATION

LIBERATION

PRINT LIBERATION

PRINT
LIBERATION

THE SCREEN PRINTING PRIMER

NICK PAPARONE & JAMIE DILLON WITH LAUREN JENISON

INTRODUCTION

YOU SHOULD KNOW HOW TO SCREEN PRINT. WE'RE THE ONES TO SHOW YOU HOW.

With at least ten years of experience each, we know the ropes. We've worked in all conditions, from exposing screens in our parents' garages to working with master printers in world-class print shops. We've printed posters, tons of T-shirts, wallpaper, boxes, stickers, fine art prints and various other things. We've had successes; we've had failures. We've been taught and we have learned by doing. Most of what we know is through trial and error, which is what screen printing is all about.

We want to give you the ability to screen print however you can, whether you're in a scary basement or a rented studio. You might have forty bucks or you might have four thousand. The beauty of screen printing is that you can make it work under almost any circumstances. This book will show you the basics of the entire process as we know it. We will show you everything from the OK low-budget way of doing something to the professional methods practiced today. You can explore the options and decide which path to take.

SCREENS MADE TO ORDER
for
T SHIRT PRINTING

CHAPTER

A SCREEN-PRINTING TIMELINE

A SCREEN-PRINTING TIMELINE

People have always needed a way to duplicate images or words and apply them to the things in their world. Whether you're trying to make artwork, spread a religion, sell a product or show people pictures of your new baby, the ability to reproduce images in mass quantities has always been a good way to get the word out.

The earliest method of reproducing images was stenciling, a tradition that has been used in some form or another in almost every culture throughout history. A stencil is essentially a template with holes cut out of it so that paint can be applied to the surface under the stencil. Stencils are often made of paper or plastic, something impermeable to paint. Stencils are practical and still have their uses, such as spray painting a lumber logo on a stack of plywood boards, but they have their limitations. The most frustrating quality of stencils is that you always need to have "bridges" of the stencil material to connect the floating parts of an image, which affects the aesthetic of the image being painted. For example, the letter "O" can never look like a big doughnut in a stencil, because that circle of white in the middle has to be connected to the outside of the stencil with "bridges." Then the "O" looks like "()."

Trying to get rid of those "bridges" sparked the development of screen printing. In Japan, printers began to use human hair and silk filament to suspend floating parts of their images. Ink could easily pass around a fine threadlike material, so the bridges were invisible. This idea probably led to the use of a net of threads, or a screen, and so the

screen-printing story began. Through trade with the West and the natural spread of information and techniques, the early screen-printing methods eventually reached England, where the screen as we know it was patented by Samuel Simon in 1907.

The commercial print industry has been the major catalyst for the development of screen-print technology. Early chain grocery stores turned to screen printing when they needed a consistent but quickly renewable way of advertising deals on apples and hot dogs. Sign hand-painters and window painters, who painted really awesome bright and graphic signs on the stores, were a little pricey and tedious, and letterpress or lithographic printing was prohibitively expensive and time consuming. The use of screen printing by these stores led to big growth in the industry. New screen meshes, inks, films and emulsions have all been created to satisfy a need to make printing even cheaper and more efficient.

The industry kept its materials and techniques largely a secret until the Depression era, when the Works Progress Administration (WPA) organized a unit of artists to work with printers. This was the beginning of screen printing's transformation into a fine art medium. However, it was a long time before the art world fully embraced screen printing, because it was viewed for so long as a purely commercial process. A sea change had to occur in everyone's perception of art before the process of making multiple originals could be accepted. This change began in the 1930s, but it became a part of mainstream culture in the 1960s when Andy Warhol and Robert Rauschenberg began using screen printing as a prominent medium in their work.

1500 B.C. to present day:
Fijians make stencils out of banana leaves by punching tiny holes in the leaves to make shapes, then push vegetable dye through the leaves. The images are printed onto handmade bark cloth.

A.D. 500 to 1000:
Paper stencils are used in Japan.

Middle Ages
(approximately A.D. 400 to 1400): Crosses are printed on Crusaders' uniforms by stretching haircloth over wire barrel hoops and blocking the nonprinting areas with tar. Stencil printing is used in combination with woodblock printing to make playing cards.

A.D. 868:
Buddhists illuminate teachings of the Buddha with stenciled designs called image prints.

Sixteenth century:
Religious pictures and manuscripts illuminated with stencils and woodblock printing are sold at shrines to pilgrims who traveled there.

Colonial America
(approximately 1492 to 1763): Stenciling is used in every nook of decoration, from painting a Federal eagle on the seat of a chair to applying repeated stenciled images to walls to look like expensive wallpaper.

Early eighteenth century:
Jean Papillon, the leader of French wallpaper technology, uses stencil techniques to supply a fashion-hungry Europe with thousands of different wallpaper patterns.

Late eighteenth century:
Japanese printers glue silk threads and hairs in a pattern to brace the floating parts of the stencils they want to print. This eliminates the "bridge" part of the stencil, which is commonly used to suspend floating parts of the design, and which dictates the aesthetic of traditional stencils. This new method of printing is called the yuzen style, a printing style that leads to the creation of a whole mesh screen, which is used today.

1870:
Printers in Germany and Lyons begin to use silk as the stencil carrier.

1890s:
The diazo process, which is the precursor to photo emulsion, is invented. It is a photographic process where a transparent positive is contact printed onto paper coated with photosensitive fluid. It is used as a proofing technique, but the technology leads to the photo emulsion with which we are familiar today.

1894:
S.H. Sharp invents a stenciling machine that is basically a revolving stencil that pushes ink through the stencil onto continuous textile yardage rolling beneath.

1907:
Samuel Simon of Manchester, England, patents the use of a silk screen as a stencil carrier. He uses brushes and paint rather than a squeegee.

1920s:
Grocery and other chain stores in the United States need locally produced signs that change frequently to advertise sales. Screen printers are able to underbid sign painters for the jobs.

1929:
Ohio screen printer Louis F. D'Autremont invents Profilm, a shellac stencil film tissue. A design could be cut out of this film and then adhered to the screen using an iron. This is a much faster technique and allows for a much sharper printed image.

WORK WITH CARE

WORKS PROGRESS ADMINISTRATION

WPA
USA

1931:
Profilm is replaced by a lacquer film called Nufilm invented by Joe Ulano, a print technician in New York. This new film is very stable and doesn't stretch when cut. Water is used to adhere the film to the screen.

1930s:
Fine arts screen printing begins as a result of a Works Progress Administration (WPA) program when a group of artists and printmakers requests that screen printing be a federally sponsored project. Anthony Velonis, a printer and painter, is chosen to coordinate the effort, and he connects many artists with screen printing. He orchestrates a self-sustaining program in which artists in the screen-printing unit produce posters to publicize concerts, plays and community events, as well as to pursue artistic screen printing. One of his goals is to create affordable artwork accessible to regular people.

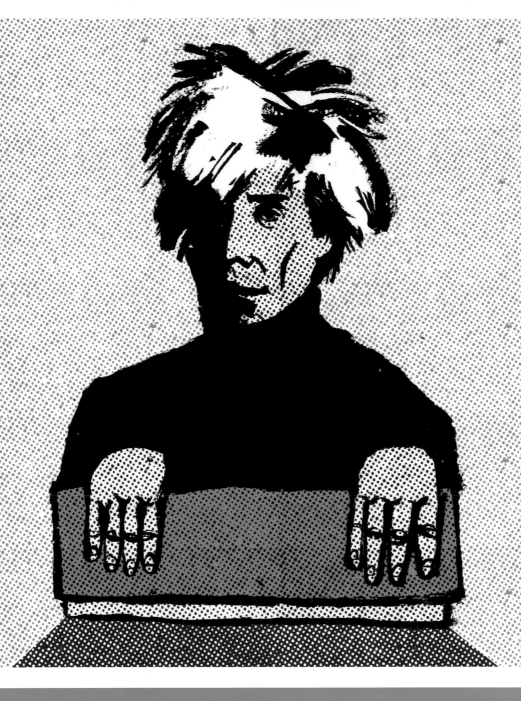

1941:
Carl Zigrosser, curator of prints at the Philadelphia Museum of Art (PMA), coins the term *serigraph* to refer to a fine art screen print, as opposed to a commercial screen print.

1960:
The textile industry uses screen printing to achieve very saturated colors. This leads to the invention of the rotary screen-printing machine, which has cylinder-shaped screens with a squeegee inside pushing ink as it turns onto fabric moving beneath.

1962:
Andy Warhol's exhibition of screen-printed Campbell's Soup cans revives and popularizes screen printing more than anything since the WPA.

1963 to 1968:
Warhol opens The Factory, which serves as a studio for his many art projects, including screen printing with his primary printer, Alex Heinrici, who is followed by Rupert Smith.

1960s:
Serigraphy becomes a defunct word in the 1960s as the distinction between fine art screen printing and commercial printing disintegrates. The commercial process is embraced as part of the work. Screen printing and silkscreen are embraced as terms for screen-printed monoprints and multiples.

1958 to 1975:
Pop Art embraces processes of mechanical reproduction, setting the trend for duplicates and ready-mades. The focus turns to the end product, not necessarily the process used to make it.

1990s:
Health and chemical regulations lead to the heavier use of other printing techniques, such as digital printing, electrostatic printing, ink-jet printing, laser-photo printing and thermal transfers. These new technologies have applications that silkscreen cannot share, such as giant plastic bus-wrap posters and graphics covering an entire side of a high-rise condominium building.

Present day:
Screen printing has been embraced as a medium of the people. Do-it-yourself (DIY) culture and open-source information lead to a totally democratic medium: Anyone can screen print, even with limited means and experience, and produce reasonably good results.

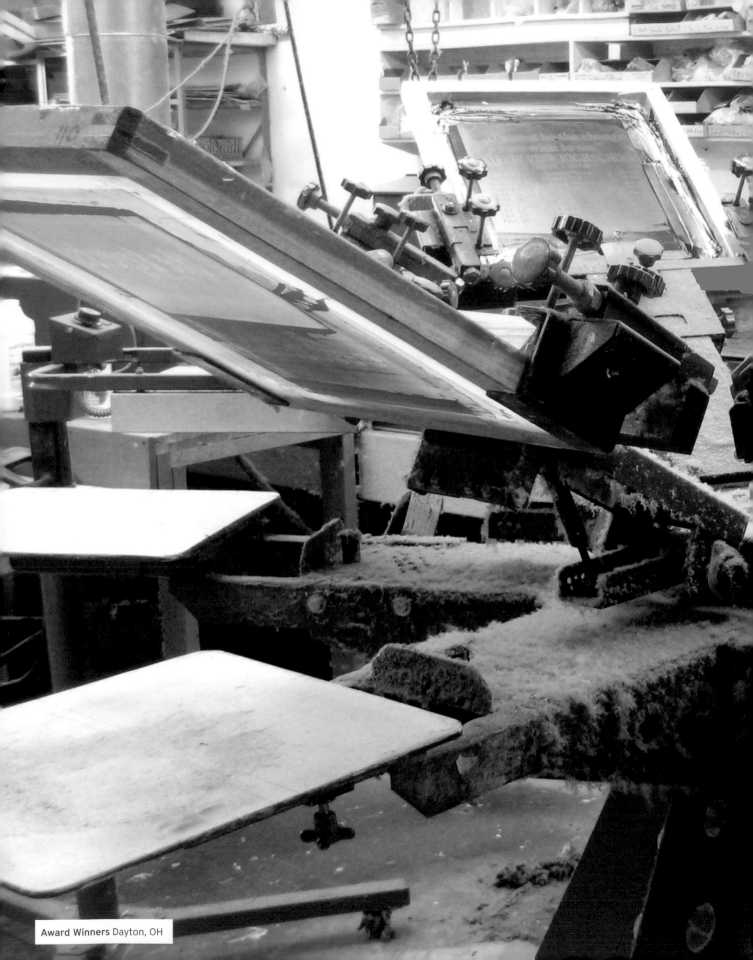

Award Winners Dayton, OH

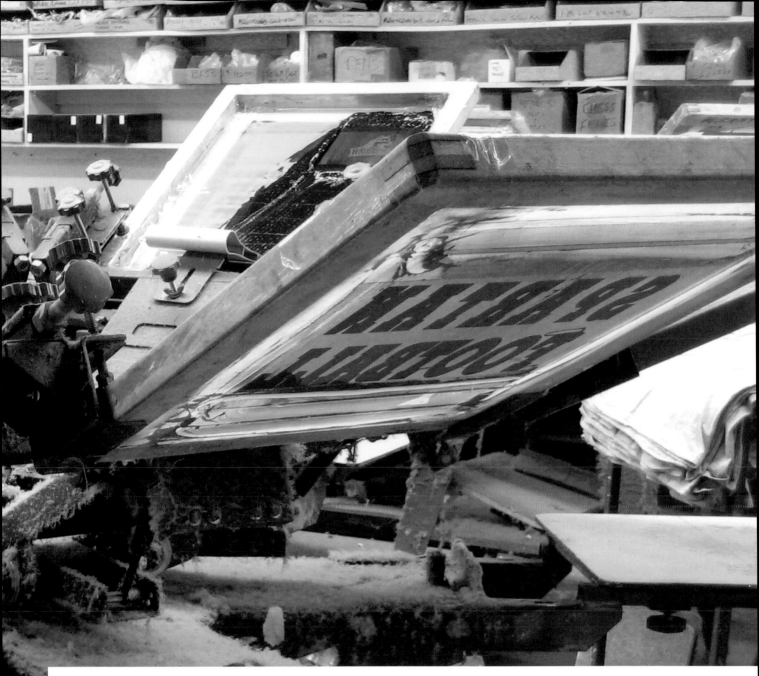

PRINT FACT: WPA

The WPA, or Works Progress Administration, was a government-funded organization created during the Great Depression to give jobs to the millions of people who no longer had work. It included training programs to qualify people for jobs, and it gave people new ownership of their lives after most of them were demoralized by the failure of the economy. One amazing fact about this organization is that 7 percent of the funds were allocated to artists, including musicians, actors, writers, folklorists, mural painters, printers and photographers.

So not only did the WPA build most of the roads, bridges and public buildings in this country, it was responsible for almost 500,000 paintings, a quarter of a million concerts and innumerable murals.

In addition to facilitating arts development, the WPA also worked to protect the art and culture of the past. The Federal Arts Project hired many workers to create an index of American design by documenting cultural artifacts, furniture and interiors ranging back to the country's founding. Writers were encouraged to participate in collecting stories for oral history archives. Extensive recordings of folk music preserved sounds that we otherwise never would have heard.

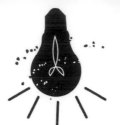

CHAPTER

2

BASIC ELEMENTS
OF SCREEN PRINTING

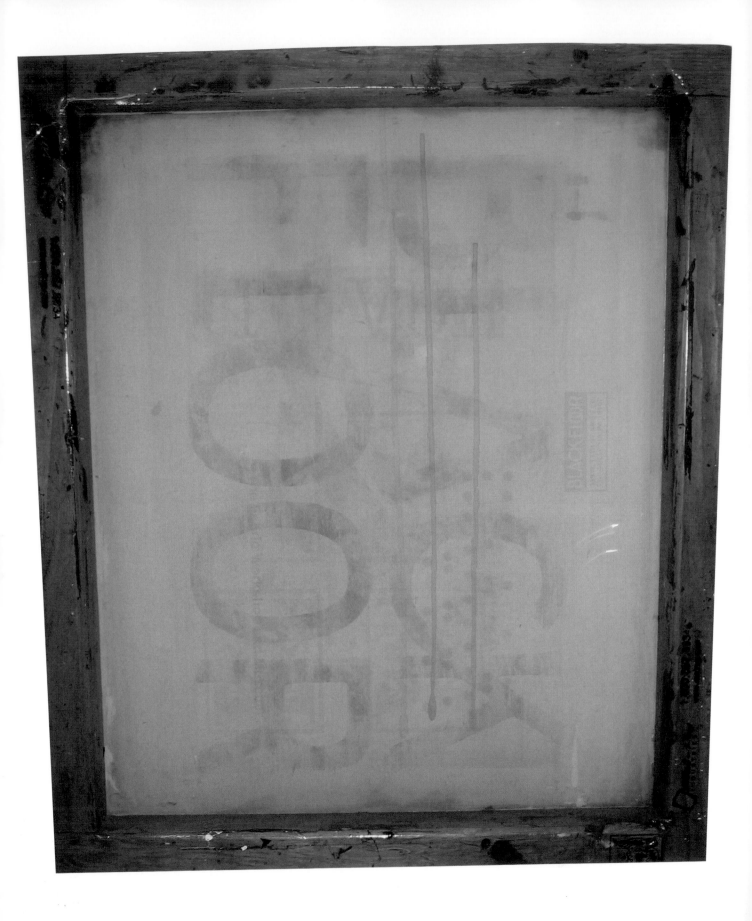

SCREEN PRINTING EXPLAINED

Screen printing is a very direct method of printing in which the printer pushes the ink through a mesh screen directly onto the substrate, or surface receiving the image. The mesh fabric stretched on a frame acts as a carrier for the image to be printed, holding the image as a stencil. Only one color can be printed at a time. To print a design with multiple colors, multiple screens must be made—one for each color of the design—and printed in registration with each other. Registration is the means for getting multiple colors to match up when they are printed. Since it is such a direct printing method, screen printing gives you control over every part of the process, and with some experience you can achieve all kinds of wonderful effects.

To make prints at your studio or home you'll need to gather some supplies that might not be familiar to you. Like a drunken man needs his wine, so you'll need the basic things outlined in this chapter to begin your days as a screen printer. While you can get started on the cheap, these things do cost money. So you might want to get a job if you don't already have one.

Screen printing can't happen without a screen. Most basically, the screen is a piece of mesh tightly stretched over a wooden or metal frame. The mesh is made of holes through which ink can freely pass. To create a screen print, some areas of the mesh are blocked so ink cannot pass through. In other areas, the mesh is left open to create the image. Ink passes through the unblocked areas of the screen, leaving the printed design on the material below the screen. Screens and screen-making materials can be purchased at most craft or art stores. You'll probably need to go to a hardware store to buy materials for making your own screen from scratch. See page 46 for instructions on making your own screen.

MESH

Mesh is the "silk" of the silkscreen. Think of it as the screen on your screen door. It is sold by the yard or by the roll. Mesh comes in different qualities, although nearly all is made of nylon. The fineness of the weave of the mesh determines the resolution of your print. The lower the number of threads per inch (or centimeter), the fewer holes there are, and the more jagged the edge of your printed area will be. The holes are like pixels in a digital image. All mesh has numbers and words printed on the very edge of the fabric. This information tells you the grade or quality of the mesh. The number is an approximate count of the number of holes per inch (or centimeter). The higher the number, the finer the mesh. A fine thread-count mesh such as 200 holes per inch (or centimeter) would be used for printing on paper, whereas a thread count such as 100 holes per inch (or centimeter) could be used to print a T-shirt. Mesh also comes in different colors. These colors affect the way light diffracts, or spreads, when the screen is being exposed to burn an image. Mesh comes in yellow, orange and white. Plain white mesh should do you right, until you begin to undertake finer-quality printing, at which point you will want to experiment with fancier screen mesh. For example, orange diffuses light the least, so it is used to print very fine, precise images.

FRAME

Mesh is stretched on frames made of aluminum or wood. Aluminum frames are very light and never warp. Wooden frames are nice and heavy and don't move around if you are printing without the frame clamped into hinges. If you are making your own wooden screen, keep in mind that the lighter the wood, the more likely it is to warp. Canvas stretcher bars are a cheap material to use, but they are likely to crap out after a few washouts. Having really stable joints at the corners is important. You'll know it's stable if the screen feels like one piece of wood, instead of four bars of wood with wonky joints. The corners shouldn't move, or become a rhombus, or teeter-totter if the frame is flat on the table. Premade wooden screens are a good bet for the at-home screen printer because they are stretched very taut and are made of solid, kiln-dried wood.

SIZE

The screen should be larger than the design to be printed to allow room on all sides for ink to sit when it is not being pulled by the squeegee. There should be at least 6" (15cm) on all sides inside the frame where there is no image on the screen. This area is called "well space," where your well of ink can sit while you're printing. Without this space, you're going to be fighting with the ink the whole time, and you want the ink to be your friend.

PHOTO EMULSION

Photo emulsion is the most common material used to block the holes in the mesh. Putting an image onto the screen is a photographic process involving coating the mesh with a thin layer of light-sensitive photo emulsion to fill all the holes. When the emulsion is dry, the screen is exposed to light with opaque artwork blocking the areas to be printed from being exposed to the light. This is called burning the screen. Then the screen gets sprayed out with water. Where the light was blocked by the artwork, the holes in the mesh of the screen are open. Where light hit the screen, the holes of the mesh remain filled with emulsion that hardened due to contact with the light.

Emulsion is made up of a base into which a photosensitive chemical is mixed. The emulsion lasts longer when stored in a refrigerator. It isn't very light sensitive when it's wet. However, as it dries on the screen, it becomes light sensitive and hardens when it comes in contact with light. Different emulsions have different exposure times. It is good to follow the exposure-time directions for the emulsion you buy, but keep in mind that exposure is the most trial-and-error part of screen printing, and you'll have to experiment a lot before you get it just right. See page 49 for step-by-step instructions on coating the screen.

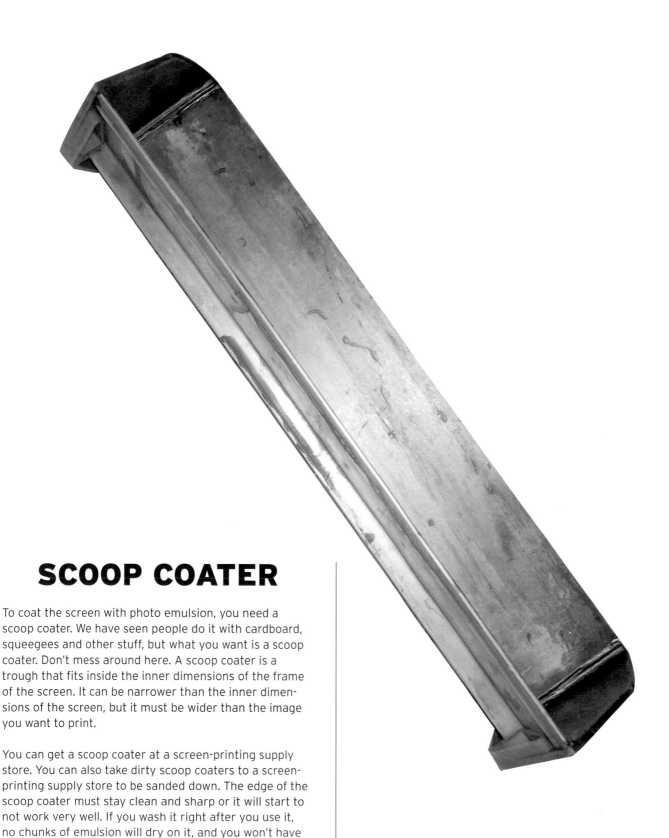

SCOOP COATER

To coat the screen with photo emulsion, you need a scoop coater. We have seen people do it with cardboard, squeegees and other stuff, but what you want is a scoop coater. Don't mess around here. A scoop coater is a trough that fits inside the inner dimensions of the frame of the screen. It can be narrower than the inner dimensions of the screen, but it must be wider than the image you want to print.

You can get a scoop coater at a screen-printing supply store. You can also take dirty scoop coaters to a screen-printing supply store to be sanded down. The edge of the scoop coater must stay clean and sharp or it will start to not work very well. If you wash it right after you use it, no chunks of emulsion will dry on it, and you won't have a problem. You must take care of this important piece of equipment, because it can be expensive and you want to keep it working well.

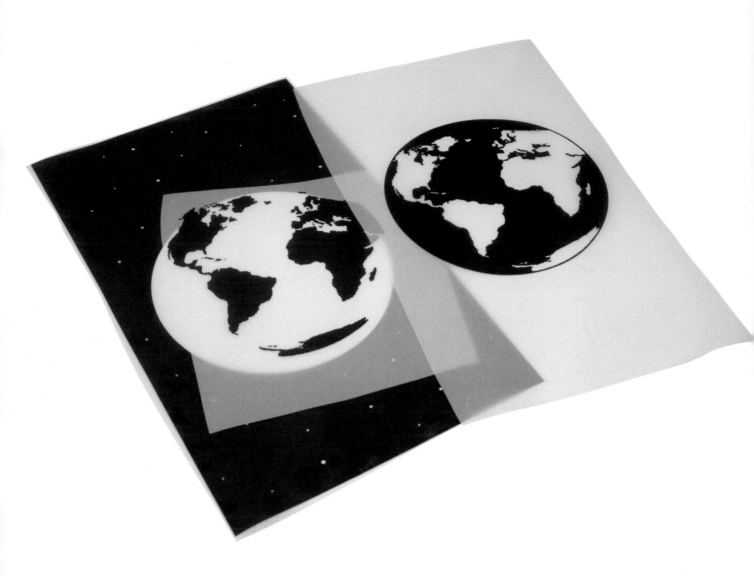

FILM POSITIVE

A film positive goes by many names: artwork, transparency, stencil, positive and Mylar. In short, it is the graphic you want to print. All the parts you want to print with your screen have to be opaque—usually black—and all the parts you don't want to print must be clear. The artwork has to fit inside the printing area of the screen.

The clear part of your film positive can be vellum, acetate or clear Mylar. Cheap film positives can be made by rubbing vegetable oil on photocopied images to make the white paper semiclear, and by then sandwiching this greasy paper between two pieces of acetate to keep it from getting oil on your screen. This method is cool, but sometimes it's a mess, and most of the time it's a crapshoot when it comes to estimating exposure times.

The black part can be pretty much anything opaque. Light cannot pass through the film positive in areas you want to print. The area where the light is blocked is the design that will print. The most commonly used film positives are computer-printed transparencies. Other film positives can be made with paint markers, India ink on a brush or in a rapidograph pen, cut paper and found objects. When you are creating the film positive, think about it as if you're making black whatever you want to print. This black design will be the open area on the screen that ink can pass through. See page 42 for an in-depth discussion of creating a film positive.

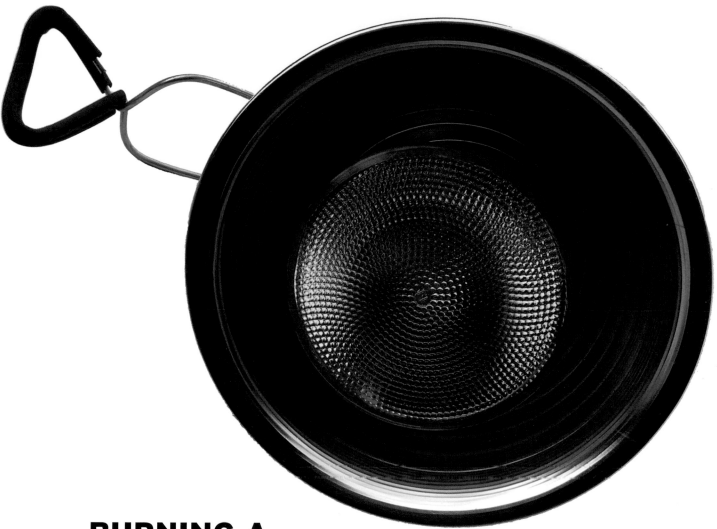

BURNING A SCREEN

"Burning" or "shooting" a screen is what we call exposing the photo emulsion to light. When photo emulsion is exposed to light, it hardens and adheres to the screen. The areas blocked from the light are then washed out. Burning the screen is the most fun and frustrating part of screen printing. It takes some practice before you get it right, but it's easy once you get the hang of it.

There are lots of different lights you can use to burn a screen. The more ultraviolet (UV) rays the light source has, the faster the exposure time will be. The sun is actually a really good UV source, and exposure using the sun is really fast. The next strongest man-made light source for UV is a metal halide bulb. Most people who are doing screen printing semiregularly and who don't have a professional exposure unit make one using UV fluorescent bulbs, clamp lights or halogen work lights. See page 52 for step-by-step instructions on burning a screen.

RECLAIMING THE SCREEN

The exposed screen can be used for printing over and over until you want to burn a new image on the screen. The mesh on the screen can be washed out using a reclaimer chemical. Reclaimer is a solvent that basically melts the hardened emulsion out of the screen mesh. It is toxic, so you have to be sure to take safety precautions, such as wearing gloves and a respirator on your face. After you reclaim a screen, you can recoat it and use it with a new image. See page 79 for step-by-step instructions on reclaiming a screen.

INK

The ink is the most straightforward part of printing. You choose the ink based on the surface onto which you're printing. Use fabric ink for fabric, mostly water-based ink for paper, sometimes oil for paper, and very toxic plastic- or epoxy-based inks for printing on metal and plastic. Professional printers mix colors using a base and pure pigments, but for at-home purposes, buying inks at the art supply store is the way to go. If you're buying a lot of ink pretty regularly, you might find some online deals for inks you can get shipped to your home or studio.

SQUEEGEE

A squeegee is the tool used to drag the ink across the screen and push it through the mesh. It consists of a hard rubber or urethane blade set into a wooden or aluminum handle. There are many different hardnesses of blades. A softer, more flexible blade will print on more substrates, while a hard blade will leave a very thin ink deposit that won't cover many substrates besides untextured paper. You can tell how hard the blade is by trying to bend a corner of it with your fingers. A medium-hard blade is good for pretty much everything. There are also different shaped tips on squeegee blades. A rounded tip pushes a healthy amount of ink through the screen and is rarely necessary. A squared-off tip or a chisel-shaped tip is good for most any printing.

We have a few different squeegees around at all times. You're going to need different sizes for different projects. The squeegee must be small enough to fit inside the frame of the screen without ever touching it. This means, at the largest, the squeegee should generally be 4" (10cm) narrower than the interior measurement of the frame of the screen.

T-SQUARE

The T-square is an essential tool for screen printing. You use it to square up all your paper, to measure stuff and to register your Mylars and prints. It gives you a sure 90-degree angle in an unsure world. Keep it around to save yourself tons of wasted energy "eyeballing" things, and being off and having to redo them.

PRINTABLE THINGS

Almost anything can be screen printed. We refer to the things we are printing on as substrates. Whatever your substrate of choice, it has to be taut under the screen and pretty smooth. Your substrate will determine what grade of mesh you use, what type of ink you use, how many times the squeegee goes over the image and what type of squeegee you print with.

If you're printing on paper, you will print "off-contact," which means that the screen will be raised just slightly off the paper (by nickels or little pieces of cardboard) so only the part of the screen the squeegee is pressing down on is touching the paper at any given time. If you're printing on fabric, it has to be stretched and pinned with

T-pins to a surface that has a little give. If it's a T-shirt, it has to be stretched on a rectangular pallet to keep the printed area really flat. Anything else you want to print on has to be treated intuitively. For example, if you're printing on the wall, just have your friend hold the screen up against the wall and drag the squeegee across the image, as if it was lying down on a table. If you need to print on the floor in the hallway at work, just stand on the sides of your screen and print through your legs. If you need to print on your sister with face-paint ink, have her hold the screen up to her cheek and run the squeegee across it like any other print. Your imagination is the only limitation. You'll learn more about printing on various surfaces in Chapter 4.

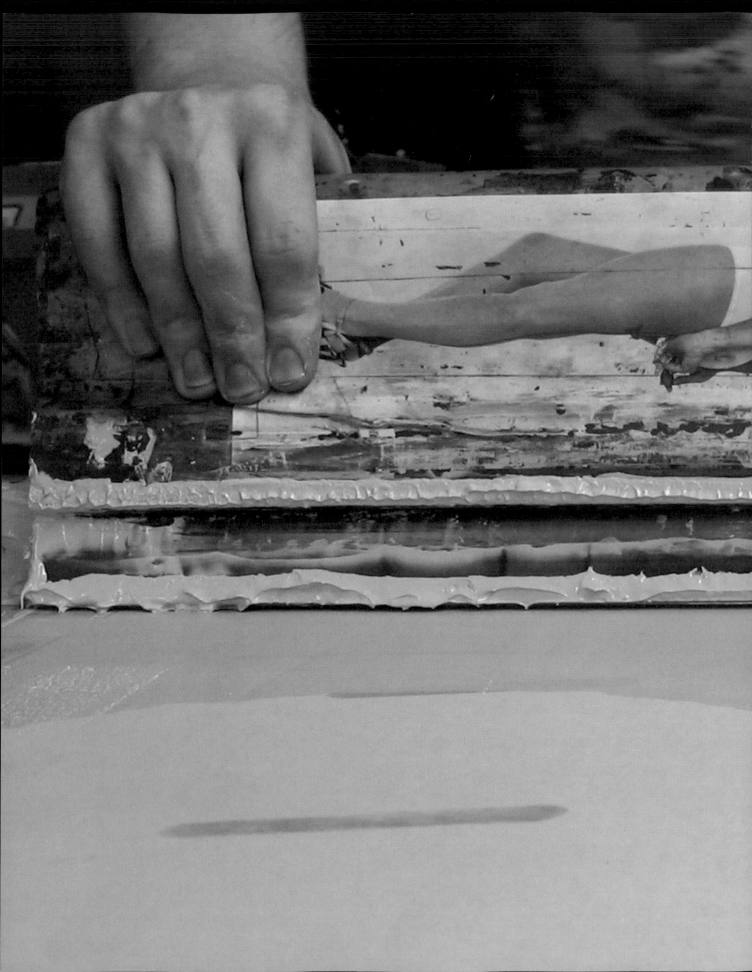

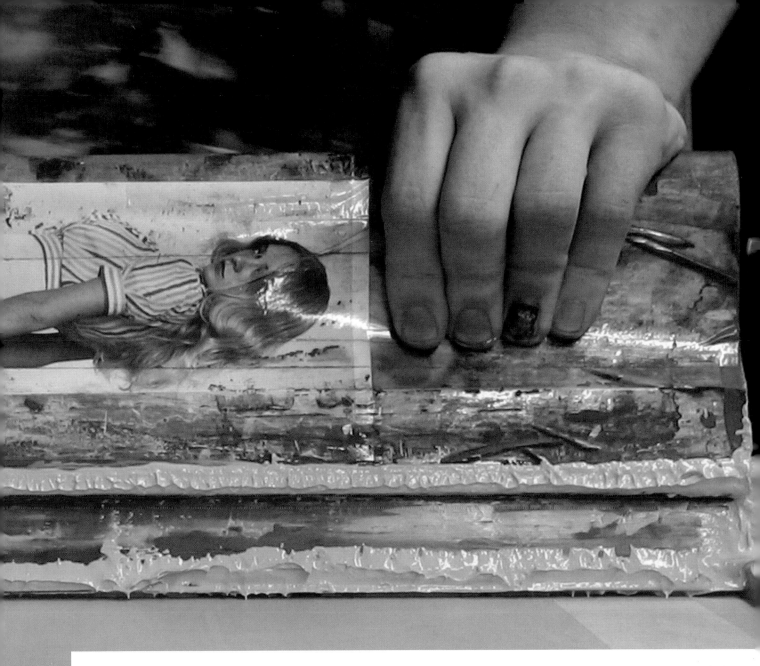

PRINT FACT: ED RUSCHA

Ed Ruscha is one of the most prolific and important artists to ever create screen prints. But he didn't just screen print with inks like we told you to. He screen printed with food and other materials to stain the paper, and he also made paintings using strange materials on canvas.

Ruscha's work is considered part of the Pop Art movement, but he produced work for so long that it naturally went through many phases. His works often include text and very graphic images and landscapes. He has made photographs, paintings, prints, books and drawings.

Printing with strange inks was a way for him to document his experiences. Ruscha was interested in smashing, breaking and destroying images and words in his canvases, and he did the same thing with the materials in the ink well. There is much video documentation of him creating these prints, one of which is called "News, Mews, Pews, Brews, Stews and Dues." For these prints, he used eggs, jams, axle grease, beer, flowers, caviar, Pepto Bismol, blood, gunpowder and chocolate syrup as his inks.

CHAPTER

HOW TO PRINT

HOW TO PRINT

Everyone's setup for printing is going to be different, but the basic elements are the same. There's a screen, some emulsion in a bucket, artwork, a light source and a sink. With a squeegee and ink, you can print the image on your screen onto anything you feel like printing.

Be forewarned: Lots of things affect how your prints turn out, and every job can turn out to be a new adventure in screen printing. What we can't predict you'll come up against could fill eighty-two more books. But, with some helpful tips and troubleshooting from us, you will be able to print on the bottom of a ship in a hurricane.

SETTING UP YOUR PRINT AREA

There are two paths to take when setting up your print area. One is to outfit a room or an area with all of your printing equipment and supplies and have that be your printing zone. The other is to pull out your equipment from nooks and lofts and under your bed and out of the bathroom when you're getting ready to print. Both ways are okay. We recommend having a printing zone, if you have room. It will save you time in setup, and you will be able to streamline your printing process. You will get a feel for where things need to be for you to work best.

TROUBLESHOOTING

- The drying cabinet/box/closet where your screens are drying should be close to your exposure unit and close to the washout sink/tub so you don't get too much light on the screen between the steps of burning a screen.

- Your printing table should be close to where you are drying your prints, whether you have a bona fide drying rack, you're drying your prints clothesline-style or you're just throwing them on the floor.

- You should give yourself a little room to move around so you aren't bumping into stuff when you're printing. If you're cramped, you will make more mistakes.

- Your printing area is going to get messy. That's life. However, trying to keep the drips, puddles, wadded-up newsprint and tape under control will save you from accidentally getting ink all over your prints and wasting valuable time.

- A second clean surface in addition to your printing table is helpful to have in the studio to draw on, dry prints and so on.

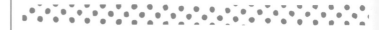

WHAT YOU NEED:

The Big Equipment:
- printing table/press
- exposure unit
- washout area/sink
- lightproof drying cabinet for screens, or a closet

The Smaller Stuff:
- printing hinges
- ink
- squeegees
- rags
- newsprint paper and junky T-shirts
- masking tape
- clock
- T-square

The Extras:
- small fridge for photo emulsion
- work surface or light table for drawing on
- drying rack for screens
- flat file for storing prints

Advanced Print Studio:
- light table for drawing your film positives
- drying rack for papers
- heat setter

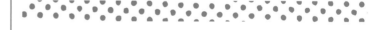

1 Set up your print studio in a space where you can get messy. Artist studios, basements, garages and sheds are ideal, out-of-the-way spots.

2 Lower a coated particle board, or other ultra-smooth piece of material, onto two sturdy sawhorse legs or onto a pre-existing sturdy table. The board should be big enough to accommodate at least twice your average screen size. You'll be setting paper and shirts on this surface as you print. Our board is 4' x 4' (122cm x 122cm).

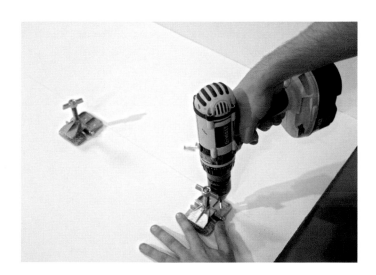

3 Two hinges hold your screen as you print. These hinges are special screen-printing hinges that can be purchased from a screen-printing supplier or art-supply store. Position one of your screens on the table to figure out hinge placement. Use a T-square to draw a level line, and screw the hinges into the table.

4 Outfit your printing area with all the materials you will need at hand while you are printing: squeegees, T-square, inks and paper. Try to keep only the essentials on your print table.

MAKING A FILM POSITIVE

Every opaque black mark you put on your film positive will print. You can use a sheet of "prepared" clear acetate from an art-supply store to draw on with a paint marker or an opaque ink, such as India ink. "Prepared" acetate has a grittier surface that ink and other media can sit on. You can cut shapes out from paper, use stickers, gouache, lithographic (litho) crayons, china markers (grease pencils), spray paint or actual objects if they're flat. Regular permanent markers don't work very well. If you're designing your image on the computer, print it out as dark as you can on a single transparency or on several transparencies that you can tile together if your image is bigger than 8½" x 11" (22cm x 28cm).

HAND-DRAWING A FILM POSITIVE

To trace something you've drawn onto acetate, you need to have a system to keep the two together so you know if you move the transparency while you're drawing. To register your acetate to your drawing, make a plus sign (+) in each corner of the drawing, then lay the acetate down and draw plus signs on the acetate aligned with the ones on the drawing. You can also print registration marks onto clear stickers and use these to register your drawing to your acetate. These help when you're doing multicolor prints because all the film positives have to line up. If you can make these plus signs form an accurate rectangle around your artwork using a T-square or a triangle, it will be helpful to you when you are squaring your film positive to your screen on the exposure unit. You can also take your original black-and-white artwork to a copy center to be copied directly onto a transparency to save you the time in tracing.

If you want to make your acetate by hand, you can begin designing your print by making a sketch on paper. Keep in mind the dimensions of the printing area of your screen. If you want to paint with ink or draw with china marker or litho crayon (opaque crayon), tape a prepared acetate over the sketch. Cover the whole area you want to print with black on the acetate (see Figures 1 and 2).

CREATING A FILM POSITIVE ON THE COMPUTER

If you are printing out a transparency, just make sure the black parts are as dark as possible. You may find that printing out two transparencies and taping them so they are overlapping will make it blacker and solve the problem of grayness. If you go to a copy or print place with your image saved on a CD, they can usually do a good job printing you a really opaque transparency. This is especially helpful if your image is larger than 8½" x 11" (22cm x 28cm), and it's usually worth the investment. In both cases—computer transparency and handmade artwork—it's fine if the acetate is cloudy-clear. It has to allow light to pass through it, but it doesn't necessarily need to be completely transparent.

USING A PHOTOGRAPH TO CREATE A FILM POSITIVE

A common way to convert photographic images into transparency form is to use halftones. A halftone image is made up of little dots varying in size and density. If you blow up a black-and-white image from the newspaper, you'll see that it is made up of dots varying in size and in proximity to each other. You can do a halftone conversion in Adobe Photoshop. These images have a powerful graphic impact and are cool looking. If you convert a photographic image into halftones, you can change the scale and size of the dots. Once you get the image to look the way you want, take it to the copy place and get them to print it out on acetate.

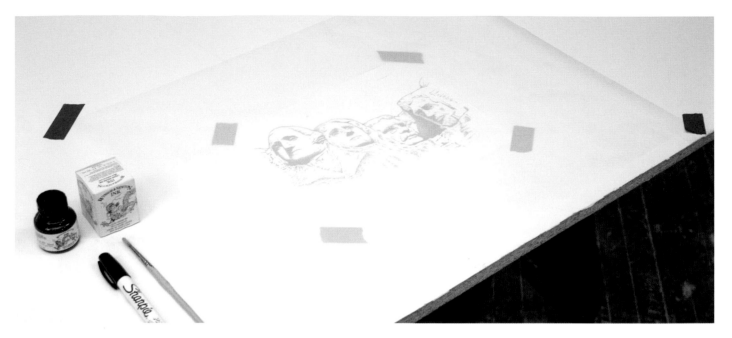

FIGURE 1

The image to be traced onto the acetate has been taped to the work surface, and the acetate is taped on top of it. At left is a black paint marker, black India ink and a paintbrush.

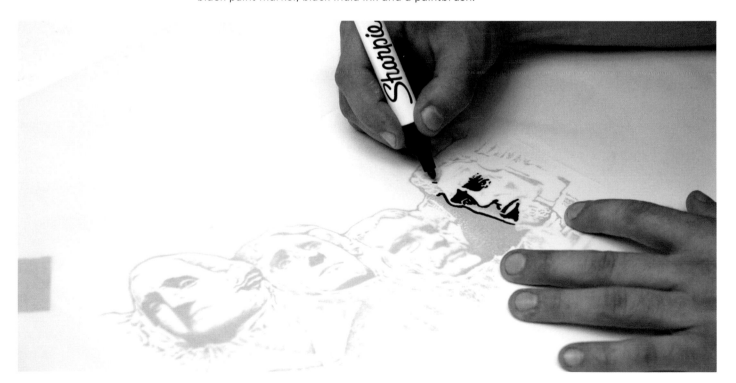

FIGURE 2

Once the image and the acetate are properly registered to each other, begin tracing the image onto the acetate with a black paint marker.

the 80's is dead

IN MEMORY OF
JON TREVOR BUTLER

MAN MAN
THE WRENS
THE A-SIDES
NYMPH

THURSDAY SEPTEMBER 20TH 2007
FIRST UNITARIAN CHURCH, 2125 CHESTNUT ST

MAKING A SCREEN

We highly recommend buying prestretched screens because your screen tension will be perfect with these screens. It's very important that your screen is consistently stretched very taut, because if it isn't, it will screw you up as it gradually moves and shifts on the frame. But it is possible to make your own frame out of wood from the hardware store if you make strong joints. You can also make a frame from stretcher bars and stretch mesh on it. If you decide to stretch your own screen, be sure to tape it off with white screen tape. This should be available at your local art-and-craft store, at a screen-printing supply store or online. The white tape keeps ink from getting into the crevices of the screen as you print and wash out, which helps keep the frame from getting soaked and warping during washout. The faster the screen dries, the faster you can print again.

A few different screen sizes are good to have around the print studio for different projects. All of the screens have to fit on your exposure unit and printing table, so those may be deciding factors in the beginning. Unless you can sneak into an art school nearby and use their big exposure unit in the dark of night—then you can make whatever size you want.

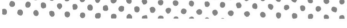

WHAT YOU NEED:

- wooden frame
- screen mesh bigger than your frame by at least 3" (8cm) on each side
- staple gun with $^3/_8$" (10mm) staples
- nylon twill tape, ideally $^1/_2$" (13mm) wide
- scissors
- canvas stretcher (optional but helpful)
- white screen tape (buy at screen-printing supply store)

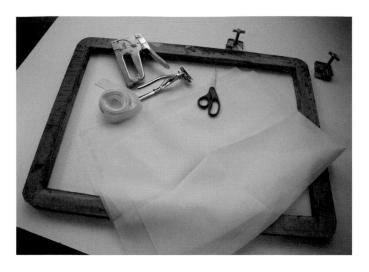

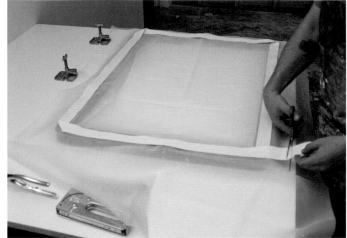

1 Collect the equipment you need before you attempt to stretch the screen. A wooden frame, screen mesh, nylon twill tape, scissors, a staple gun and staples are necessary. A canvas stretcher is helpful.

2 Lay the screen mesh flat on the wooden frame. The screen mesh should be bigger than the exterior dimensions of the frame by 3" to 4" (8cm to 10cm) on each side so you can pull it. Lay the twill tape along the frame, making a 90-degree fold at each corner. Allow approximately 2" (5cm) of the twill tape beyond the edge of the frame before cutting it.

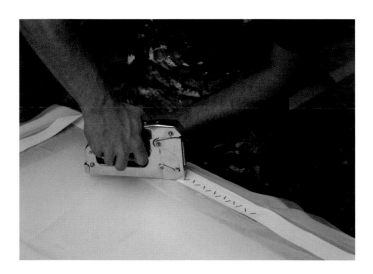

3 Beginning in the middle of one of the longer sides of your frame, staple every 1/2" (13mm) with 3/8" (10mm) staples. Stretch the mesh as you go. Staple at alternating 45-degree angles through the twill tape and the mesh so the mesh doesn't rip.

4 Staple about 5" (13cm), and then switch to the opposite side and do the same while stretching it toward you. It's like stretching a canvas. Then staple 5" (13cm) of the other two sides.

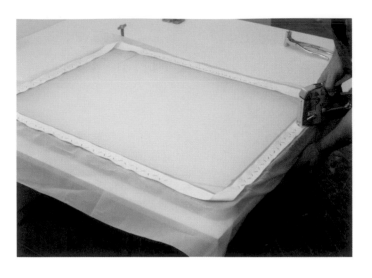

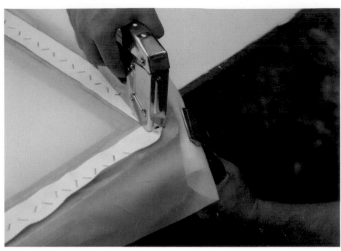

5 Go back to the long sides and secure 3" (8cm) more on the left and right of what you stapled already, stretching the mesh down and out.

6 Gradually work your way out from the middle of each side until the entire screen is stretched taut. Then cut off your extra mesh.

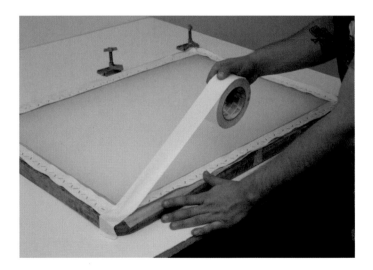

7 Use white screen tape to cover the whole wooden frame. Start by covering the staples on the flat side of the screen, starting about $\frac{1}{2}$" (13mm) into the printing area. Work your way out, overlapping a little each time. Be sure to cover $\frac{1}{2}$" (13mm) into the screen on the squeegee side too, so there is no sticky part exposed.

8 Look at you! You did it!

COATING THE SCREEN

The screen must have a thin, even, nonbubbly layer of emulsion on it to expose well. Follow the instructions included with the box of emulsion to know how to mix the different chemicals in the emulsion. It's really simple. Right after you mix the photosensitive chemical into the emulsion, the mixture will have a lot of bubbles in it. It's better to wait an hour or two after mixing it to let the bubbles pop before you coat your screen. If it's your first time using this screen, this is a good time to wash the screen with dish soap and water, or use a degreaser to break down any oil on the mesh. Rinse it off and let it dry before you coat the screen.

TROUBLESHOOTING

- You want the emulsion to be super thin. The places where it is chunky or thicker won't shoot the same as the rest. Uniformity is key.

- People have different ways of coating a screen. Some do it on one side, then flip it around and coat the other side. Some people do one coat and then pass over the emulsion a second time with an empty scoop coater. Some people hire other people to do it for them. We think you can do it. If you don't like it our way, try another way. Different strokes for different folks.

- Make sure there are no really globby parts on the edges of where the scoop coater scooped. The problem with leaving these areas thick is that they will drip down into your printing area as the screen dries and ruin your perfectly even coating job.

- The screen also shouldn't touch anything when it's wet, so don't run into your roommate when you're running to your dark box, and don't lean it up against the clothes in your closet.

- After you coat the screen, place it in a dark closet or box to dry. As you know from reading about emulsion, it becomes light-sensitive when it's dry and is semi light-sensitive when it's wet—like a piece of photo paper. (Don't forget to put your lid right back on your emulsion bucket.) You want your drying area to be fairly close to your exposure unit so you can turn off the lights, get your screen out of the closet, run over and throw it on the exposure unit to expose it without running into much light. If you can, dry the screen horizontally, so the emulsion doesn't drip

and become uneven as it dries. An electric fan really speeds up the drying, if you can fit one into the space where you're drying your screen.

- Emulsion is affected by a million variables. Humidity, age, drying time, whether your cat peed on it, how long you shot it, how gently you washed out the screen—all these things can make or break your exposure. It's an organic, intuitive process of learning with this stuff. You can't always predict everything, and, more than likely, you'll have to start over again on a few screens. Don't give up! The more times you do it, the more you know what to expect. Even if what to do is not spelled out exactly in this book or on the bottle or in another book, soon enough you'll be able to toy around with things until you get your screen shot just how you want it.

WHAT YOU NEED:

- scoop coater
- sensitized photo emulsion
- degreased, stretched screen
- newspaper or butcher paper for catching drips

49

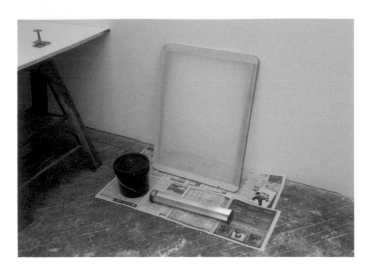

1 Lay down some newspaper or butcher paper. Prop up the screen against the wall at an angle, with the back of the screen facing you. (Note: We are using a prestretched screen purchased online.)

2 When the emulsion is ready, pour a thin bead of it into the scoop coater trough along the entire width. You don't want to fill it all the way to the brim, just three-quarters or halfway full. Press the long, sharp edge of the scoop coater against the bottom of the screen. Make sure the scoop coater is level (parallel, in other words) with the top and bottom of the screen.

3 Tilt the scoop coater so the emulsion runs forward onto the screen. Once it's touching at all points, begin to slowly drag the scoop coater up the screen.

4 Press firmly against the screen. Drag the scoop coater up about 3" (8cm) per second. Be consistent and graceful, not jerky. Keep it moving, or you'll get a thick spot that will expose differently than the rest of the screen.

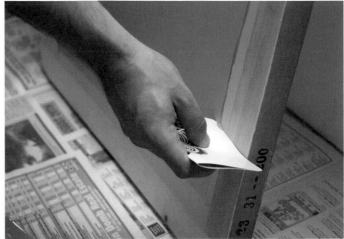

5 When you get close to the top of the screen, tilt the scoop coater back toward you with the edge still pressed firmly against the screen and let the emulsion run back in. Then swiftly scrape it up and off the screen, trying to prevent a big glob at the top. If there are uneven areas, you can scrape the sharp edge of the scoop coater up the entire screen without tilting it forward (so more emulsion is not applied to the screen) to remove excess emulsion. Repeat steps 3 through 5 as directed by the emulsion's manufacturer's instructions.

6 Run a folded postcard or a piece of cardboard with a hard edge up the sides of the coated screen (as if you had a small empty scoop coater) to scrape off the surplus emulsion on the edge of the screen.

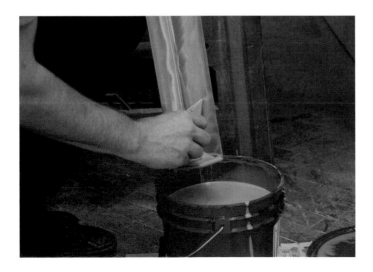

7 Use the same postcard to scrape as much emulsion as you can back into your emulsion bucket. Firmly put the lid back on your emulsion bucket and try to store it in a dark place.

8 Thoroughly wash out your scoop coater, paying special attention to the long flat edge that is pressed against the screen. Always keep this super clean.

BURNING A SCREEN

Burning a screen on a homemade exposure setup is so simple. All you have to do is harden the light-sensitive emulsion with a light source you place above (or in some cases below) your screen. Then you wash out the parts that don't get hardened by the light, and you have your silkscreen.

TROUBLESHOOTING

- If all of your screen, not just the part you want to print, starts washing out, you underexposed it. Try shooting the screen for a longer time.

- If your screen has tons of pinholes, you under-exposed it.

- If your screen is sticky after you wash it out, it is underexposed. This can be fixed by burning the screen under the exposure unit again when it's dry. Just make sure the areas you want to print are washed out really well.

- If your image looks a little smaller than you remember it, and just a little crappier, there's a chance you overexposed it. You can reclaim, recoat and shoot it again, or you can just roll with the punches and print.

- Make sure the area where your screen dries before you shoot it isn't humid. Humidity really throws a wrench in the works for emulsion. If worse comes to worst (you live in the Midwest and it's August), get a dehumidifier.

- If your emulsion is washing off in skins around the area that opens up, you probably began with too thick a coat of emulsion. Try doing a thinner coat of emulsion.

- If your emulsion is blowing out in some parts, but not others, in the area of your design, you might have coated unevenly. Another possibility is that your exposure unit is lit too unevenly. Consider getting two clamp lights or using another exposure technique, such as building a box the screen can sit in and lighting it from below.

WHAT YOU NEED:

- screen coated with photo emulsion drying in a dark place
- dry, completed film positive
- light source with lots of UV
- vague idea of how long you want to shoot the screen, based on experiments or on research you've done about your kind of exposure unit or what you read on the emulsion box
- piece of glass the size of your printing area
- shelf bracket
- piece of foam about the size of screen's interior frame and about 1" (3cm) higher plus a black T-shirt
- palette knife
- drill
- small jar or cup of emulsion

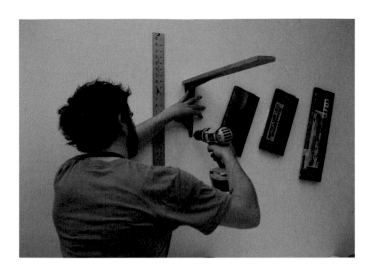

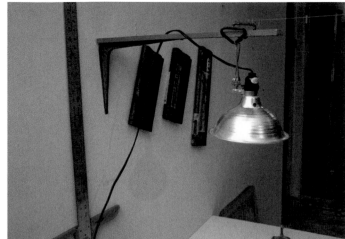

1 Screw a shelf bracket with a long piece of wood attached to it into the wall above the table where you will be exposing your screen. Make sure the piece of wood is long enough so that a light hanging from it can be roughly centered on your screen. The light needs to sit about 34" (86cm) above the surface of your screen.

2 Figure out a way to hang the light onto the piece of wood. Point it down and try to center it. The bulb you have in the light should have as much UV and be the highest wattage you can get, ideally 500 watts and up. (Be careful—make sure your light fixture can safely handle a high-wattage bulb.) The light needs to be evenly dispersed across the entire screen, so check to make sure your light will be evenly distributed across your printing surface.

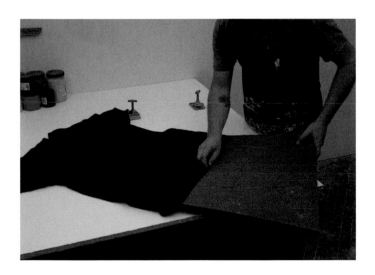

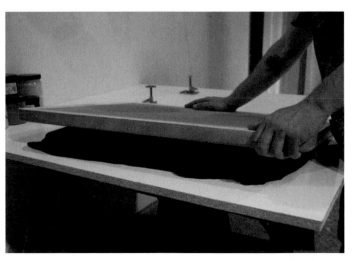

3 Take a piece of squishy, flat foam the size of the interior of your screen's frame and about 1" (3cm) higher and cram it into a black T-shirt. This will muffle the light that comes through the screen so it doesn't scatter and make your image blurry.

4 Turn off the lights! Go get your screen from the dark closet. Lay the screen down, flat-side up, on top of the T-shirt/foam insert.

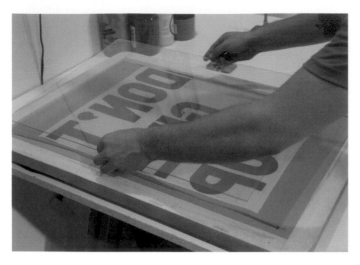

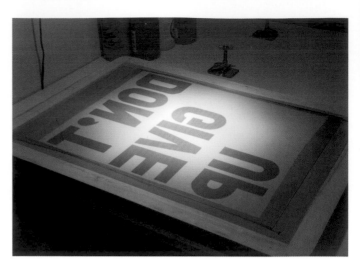

5 Lay your reversed film positive on the center of the screen. This means flip it. So if there was writing, it would be backwards, as in a mirror. Then lay the piece of glass over the film positive to hold it down really close to the mesh of the screen during exposure.

6 Turn that light on.

7 Burn the screen for your predetermined amount of time. This might be something like twenty to twenty-five minutes for a 500-watt light, depending on what kind of bulb it is. When that time has elapsed, turn off the clamp light.

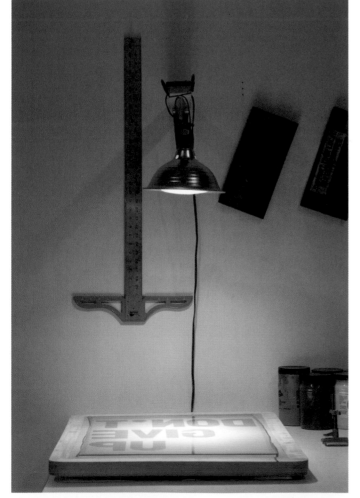

8 Run your screen over to the sink or shower or hose where you will be washing it out. Get the front of the screen and the back of the screen wet as soon as you get there. This stops the emulsion from being light sensitive. Then you can turn the lights on. A ghost image of what you exposed will begin to develop.

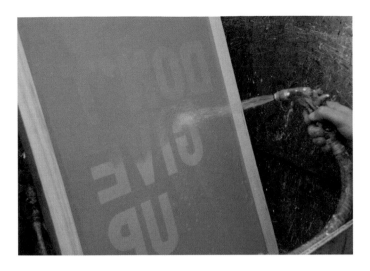

9 Spray with moderate force all over the screen, focusing on the areas where your design is supposed to wash out. It will take a minute for the emulsion to soften enough to wash out. Be sure to spray off both the front and the back of the screen.

10 Hold your screen up to a light source to make sure you washed out all the parts you want to print. Make sure there are no milky-clear areas or residue. If there are, or if there are little corners that still have emulsion in them, wash them out more.

11 After your screen is washed out and dry, you get to pinhole! Prop your screen up where you had it to coat, flat-side up, and put a light source behind it on the floor. Look for any areas where there are open holes in the screen mesh that you don't want to print. This is anywhere you can clearly see light through the screen.

12 Pour photo emulsion into a small cup and close the big bucket's lid.

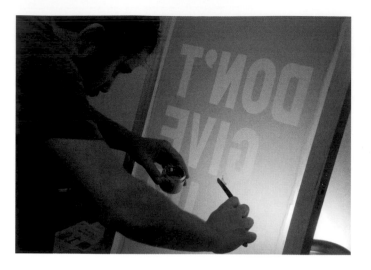

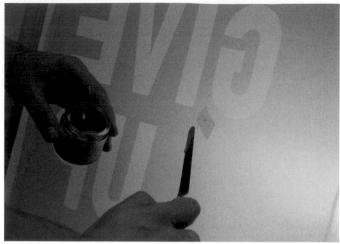

13 Using a painter's palette knife, get really close to the screen and fill in any holes you see with photo emulsion.

14 Scrape the excess photo emulsion off so you're left with a thin patch over the hole. You might have a lot of holes. This can result from air bubbles in the emulsion, underexposure, or a dirty glass/film positive. Let the screen dry for a while in the light so the emulsion hardens as it dries.

PRINTING A ONE-COLOR POSTER

So hopefully your screen looks like a million bucks. Now you're ready to break in your new printing press. Why not start by printing your own poster? Printing on a poster is very straightforward and rewarding. It makes you feel like you can plaster whatever you want all over the world. The same principles apply to printing on any paper, pretty much, so once you master this you can do a lot of things you couldn't do before.

TROUBLESHOOTING

- If you notice part of your image isn't printing correctly, many things could be going wrong: The screen may not have been washed out properly after exposing it; you might not have pressed the squeegee down hard enough while printing; the squeegee you chose might not have been long enough to apply adequate pressure on all sides of your image; or you might not be eating enough fiber. If the image isn't printing properly after ten or so prints, it's probably a good idea to stop, clean up and examine your screen. Try printing again after you wash out and examine the screen. Sometimes this magically fixes it, like rebooting your computer. You never know.

- As you are printing, small pinholes may develop. A quick remedy for this is to put small pieces of clear packing tape on the back of the screen over the pinholes in the midst of printing.

- The emulsion may begin to deteriorate after a lot of printing with the same screen. This could stem from the emulsion being old, improperly mixed or poorly exposed, or just from natural wear and tear. If the emulsion does start to wear down, it's best to start over and burn a new screen.

- If your paper is sticking to the screen, it may be due to the weight of the paper you are printing on, or the amount of ink used in your design. It's not that big of a deal; you can just gently pull the paper off the screen without smearing the wet ink. Lightweight paper will inevitably wrinkle and look crappy overall. If your design has a lot of ink coverage you may need to occasionally spray a very light coating of spray adhesive to keep the paper on the table. Professional printers use a vacuum table that sucks the paper down to solve this and other problems.

- If your image starts to become hazy-looking as you're printing, it most likely means you aren't moving fast enough and the ink is drying in the screen. To fix this problem, you can wet a rag and wipe the image area on both sides of the screen. Then do a few test prints on scrap paper until the image is printing properly again.

WHAT YOU NEED:

- exposed and pinholed screen film positive
- blue painter's tape or masking tape that won't rip paper
- 4 small squares of cardboard, or 4 nickels
- clear packing tape
- ink
- squeegee
- test paper
- poster paper, or whatever you're printing on (heavy-weight, good-quality paper works best)
- rubber spatula
- rags
- sponge

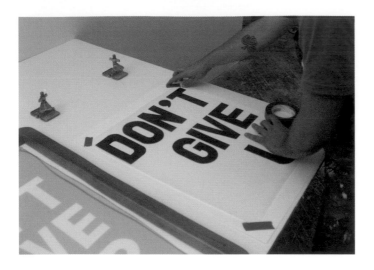

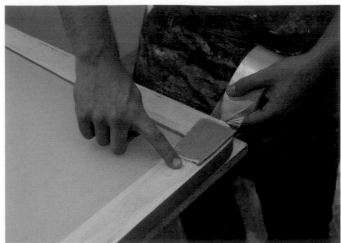

1 Tape your original film positive into position on your poster with blue painter's tape. This is when you can decide on the placement—if you want more white space on the bottom or if you want the image centered all around, and so on.

2 Tape little squares of cardboard, or nickels, into the two lower corners on the flat side of the screen. This keeps the screen "off contact" so the wet ink doesn't slowly ooze up through the screen and leave weird marks in the design as you're printing.

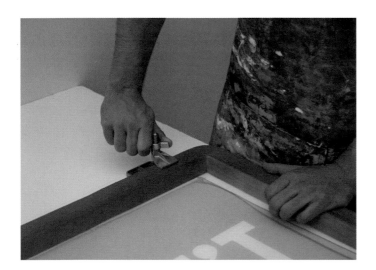

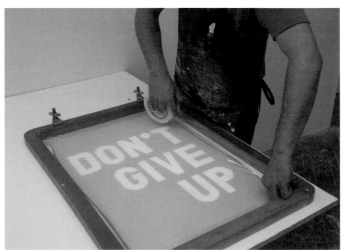

3 Clamp the screen firmly in the hinges so the entire screen is resting on the print table with some extra room around it.

4 Apply packing tape to the areas around the printing area that didn't get coated with emulsion. Create a corner with the tape so the ink cannot escape out the sides and under the frame during printing.

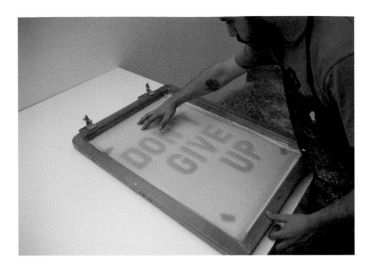

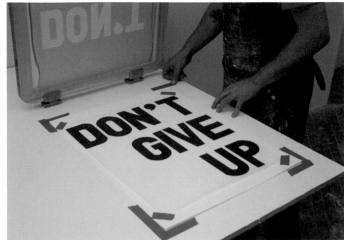

5 Retrieve that paper you taped the film positive to and slide it under the clamped screen. Move it around until it matches up perfectly with the image burned in the screen.

6 Gently lift up the screen so it's out of the way (you may have to prop it on something) and be sure not to move the paper. Make a blue tape "L" on the print table exactly at each corner of the paper. These tape Ls will tell you where to put the paper each time you make a new print. Then remove the film positive taped to the paper.

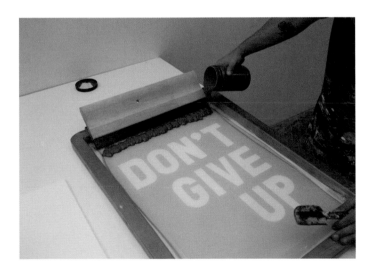

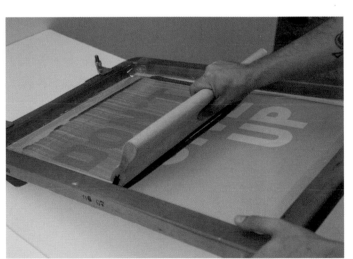

7 Pull the screen down and gently rest it on the table. Rest your squeegee tilted away from you on the far side of the screen. Make sure your squeegee is long enough to cover your entire image. Pour a bead of ink on the side of the squeegee facing you. The bead of ink should be about 1½" (4cm) thick and run the whole width of your squeegee.

8 Now you're ready to flood the screen. To do this, hold the screen above the paper. Firmly press the squeegee and ink against the screen and pull it toward you. Tilt the squeegee at a 60-degree angle. When it gets past the whole printing area, lift it over the ink and push it back where it came from, without changing the angle of the squeegee. Then rest the squeegee on the far side of the frame again.

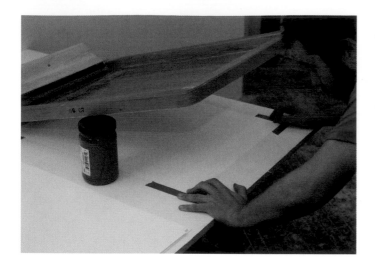

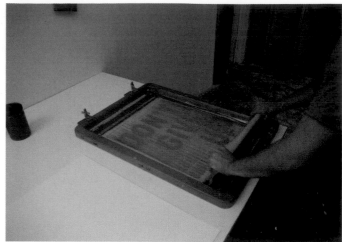

9 Prop the screen up on an ink jar, your head or some other object around you. Place a fresh piece of paper in the registration marks you made with tape on the table in step 6.

10 Gently lay the screen down on the paper. Grab the squeegee with both hands, place it behind the ink and pull the ink toward you while pushing down really hard with the squeegee. Make sure to keep the squeegee at a 60-degree angle for the proper ink coverage.

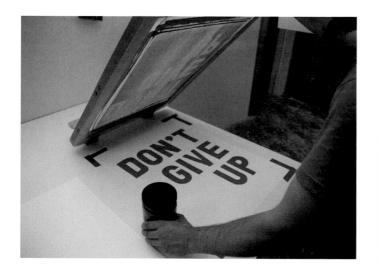

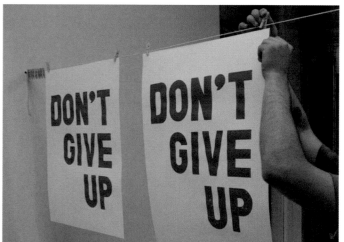

11 Lift up the screen and flood it back to the far side of the screen again. Then prop it again on your ink bottle or something on the table. This will be your pattern for printing.

12 Carefully move the wet print to a drying area. You can pin it to a clothesline with bulldog clips or clothespins, or lay it flat on another table or the floor or on a bona fide drying rack. Repeat until you are sick of your poster. You can add more ink, if you need to, as you print.

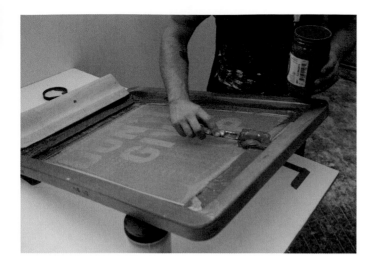

13 When you are finished, use a spatula to scrape the leftover ink into your ink jar.

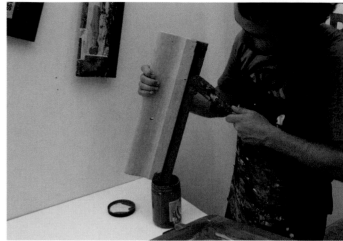

14 Scrape the extra ink off your squeegee into the jar too.

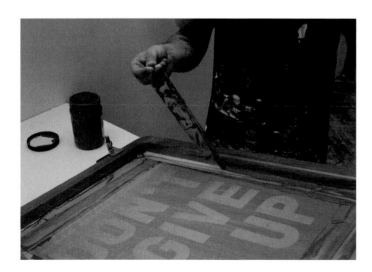

15 Pull off the packing tape and throw it away.

16 Wash out the screen with a sponge. Be sure you get the front and the back, removing all traces of the ink. Some of the color might stain the open areas of the design, but that's okay. Wash your spatula and the squeegee, too.

NWA WORLD TITLE MATCH
FRIDAY NIGHT
BLOODY HELL

HARLEY RACE VS. BRUISER BRODY
2 OUT OF 3 FALLS
FEBRUARY 23RD, 1979

PRINTING A THREE-COLOR IMAGE

Printing a three-color image is a little more complicated than printing a one-color image, but the complication lies mostly in the preparation. When designing the transparencies, keep in mind that only one ink at a time can print through a screen. For the most part, the rule is one color per screen. Multiple colors are usually printed lightest-colored screen first to darkest-colored screen last. This is so that something called "trapping" can work. Trapping is overlapping the edges of the design on each transparency so there is less chance of visible mess-ups if you're a little bit off registration. It's a nifty way of giving yourself a window of error. The colors sit on top of each other a little bit, and the print looks normal. So, account for this in your designs for multiple colors.

TROUBLESHOOTING

- Most likely your registration will be off at least once. This is a common error in screen printing and many people actually enjoy this look. If all of the prints are off, your initial registration is probably off or maybe you didn't do enough trapping on your Mylars. It is also possible that your screen moved slightly because the hinges weren't tight enough.

- It is possible to accidentally burn one or more of your Mylars backwards on the screen. Depending on your design, this may or may not affect the registration or print overall.

- With lots of ink coverage, the paper may wrinkle greatly or slightly, depending on the paper you choose. To avoid wrinkling, always print on good-quality, thick paper (80-lb. and heavier, or 18gsm).

WHAT YOU NEED:

- three screens, shot, pinholed and taped off with clear tape
- Mylar film positives
- blue painter's tape
- postcards or cardstock
- paper
- scissors
- ink
- squeegee
- rubber spatula
- sponge
- spray adhesive

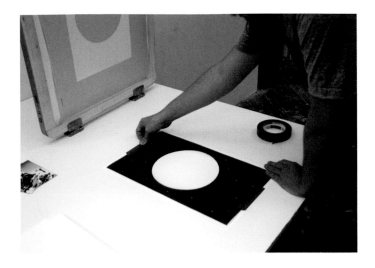

1 Tape your largest Mylar film positive in printing position onto the printing paper with colored tape. By using the largest one, you can orient the print exactly in place on the paper much more accurately than you can with a little guy.

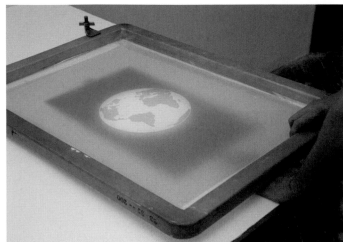

2 Secure your first screen into the clamps. This will be your lightest color. Pull it down just over the surface of the table and move the paper with the Mylar taped to it around until the two screens perfectly register to each other.

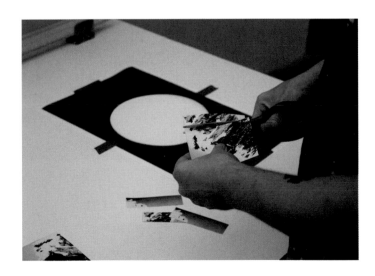

3 Tape the piece of paper with the Mylar on it down to the table without moving it. Cut a postcard or cardstock into 1" (3cm) wide strips. You're going to use these to make the "L" registration a little beefier, so that the paper fits real snug into it and doesn't go anywhere while you're printing.

4 Lift the screen up and tape down "L" registration with blue tape on each corner, with postcards under the blue tape to make it an actual "tab" the paper can fit into when it's registered correctly. Do this on only three corners so it's easier to get your paper in and out of the registration tabs.

5 Place your first, fresh piece of paper in the registration marks.

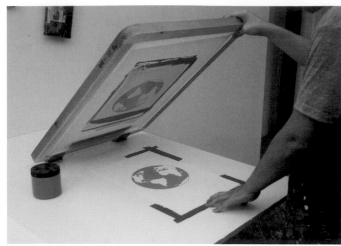

6 Using the same flooding and pulling technique you used for the one-color poster (see pages 59-61), print your entire run of paper with the first color of the design. Be very careful to register them all the same.

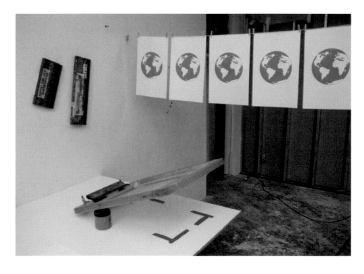

7 Hang your prints up to dry and admire your work.

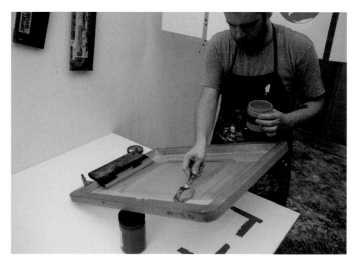

8 Use a spatula to clean the ink off your screen and squeegee, and wash them out. Be sure to wash both sides of the screen and use a sponge.

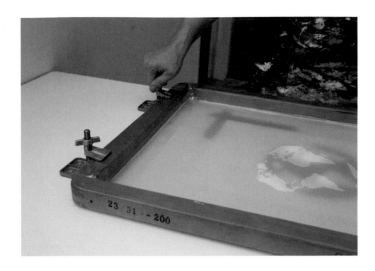

9 Clamp your second screen into the clamps. Use one of your first prints to line up where the paper should go to perfectly register with the second screen.

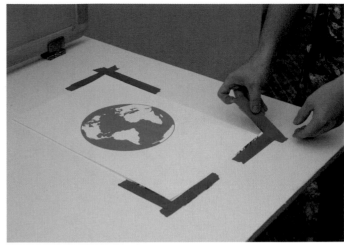

10 Take off the registration marks from the first color print, and tape them to the edge of your print table for reuse.

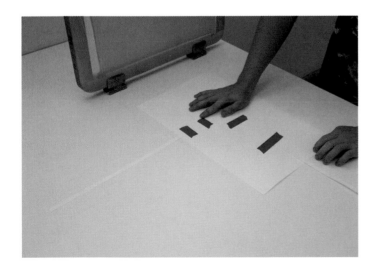

11 Flip over the first print you are using to register the second screen. Use painter's tape to tape two long strips of paper to the back of the poster in a cross, one going down and one going out. These will be your puppet strings as you register the paper. Flip the paper back over.

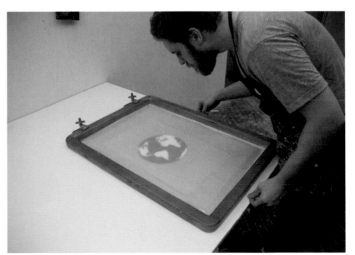

12 Lower the clamped screen down over the face-up print. Use the two strips of paper to move the poster under the screen until you get it registered perfectly.

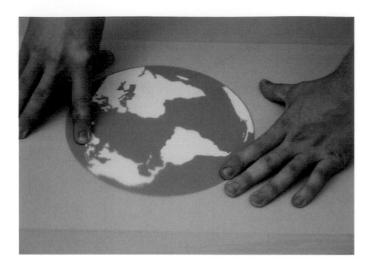

13 You may need to press down on the screen to see what the registration looks like when it's totally flush with the print. This is the most accurate way of seeing how it will really print.

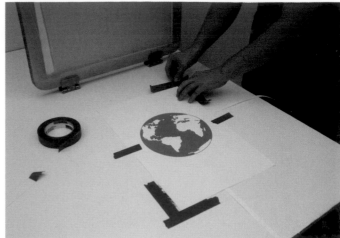

14 When you feel you have done your very best, put two small pieces of blue tape on either side of the registration print to make sure it doesn't go anywhere. Then place your "L" registration tape back down on each corner where the print now lies.

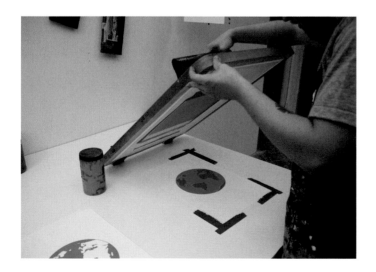

15 Use this registration to print your second-color run.

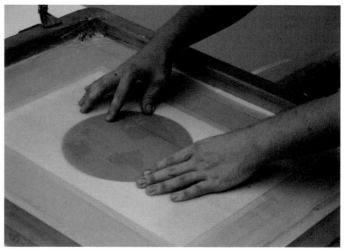

16 Use the same techniques to register your third color.

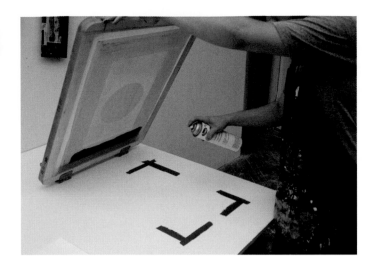

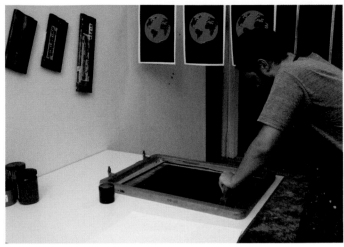

17 If you're printing a color that covers a large area of your paper, spray a little bit of spray adhesive down on the table under the paper every once in a while during the print. This helps the paper to stay flat and not buckle up. Otherwise, the print may want to cling to the screen when it's really wet.

18 Print your third color as you printed the other two.

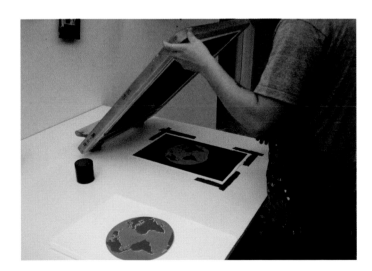

19 Amazing, isn't it? The Earth, from space?

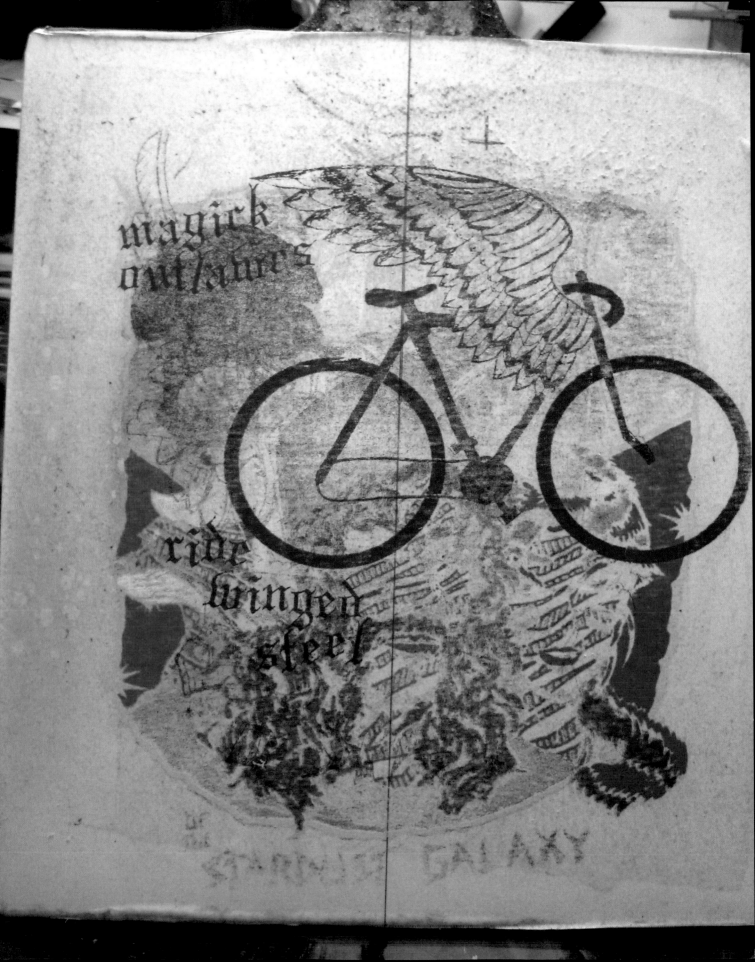

magick
outlaws

ride
winged
steel

of the
STARDUST GALAXY

BUILDING A ONE-COLOR T-SHIRT PRESS

Building a T-shirt press is really the only way to go if you're printing more than even just a couple of T-shirts. It's painless, as far as carpentry goes, and it instantly turns you into a speedy professional T-shirt printer. It will save you a lot of time and a lot of tears, and anyone with a drill and saw can do it. Take note that this is the simplest way of building a T-shirt press. Feel free to modify this design to accommodate your printing needs.

WHAT YOU NEED:

- 1" x 12" x 2' (3cm x 30cm x 61cm) piece of quality wood (such as poplar) (Remember that 1x in carpentry actually means $3/4$" [2cm])
- $3/4$" (2cm) piece of smooth melamine board (pre-cut shelving works great) with maximum dimensions of 15" (38cm) wide and 16" (41cm) long
- four pieces of 1" x 4" x 15" (3cm x 10cm x 38cm) quality wood (poplar)
- drill
- $1/4$" (3cm) wood screws and 2" (5cm) wood screws
- wood glue
- screen-printing hinges
- measuring tape

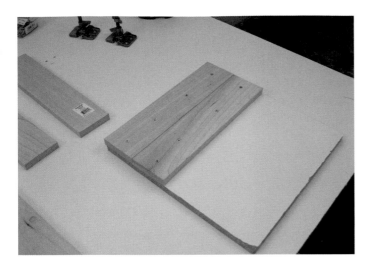

1 As shown in the photo, attach two 1" x 4" x 15" (3cm x 10cm x 38cm) pieces of wood to the smooth board using the 1¼" (3cm) screws. Remember to countersink the screwheads below the surface of the wood.

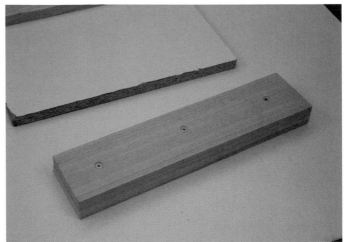

2 Make a spacer by doubling the remaining two 1" x 4" x 15" (3cm x 10cm x 38cm) pieces of wood, again using 1¼" (3cm) screws.

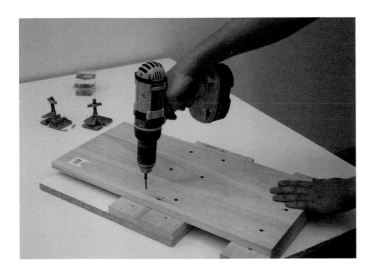

3 Using a measuring tape, center the spacer, smooth board and the 1" x 12" x 24" (3cm x 30cm x 61cm) poplar panel to each other. Attach the spacer and smooth panel flush with opposite ends of the poplar panel.

4 Turn over the T-shirt press, and it's ready to use.

PRINTING WITH THE T-SHIRT PRESS

Now that you've taken the plunge and built that T-shirt press, you have to use it. The hardest part is over—printing with the T-shirt press is easy! All it takes is a little bit of patience and care to be sure you're printing in the right place on the T-shirt. As long as you don't get cocky and you pay attention to what you're doing, you will be your own T-shirt factory. Now you can finally make all those clever shirts you have been thinking about, smarty.

TROUBLESHOOTING

- When printing with light-colored inks on dark garments you may notice the colors appear very faint. A technique called "flashing" is used to make these kinds of prints brighter and you happier. Flashing is basically applying two layers of ink to your substrate. Put plenty of adhesive on the pallet so the shirt doesn't move, print the first layer, then dry it as much as you can using a heat source for thirty seconds. Then print the second layer.

- Printing smaller-sized garments will require you to stretch them over the pallet, which can make prints look distorted. Consider the average size of garments you'll be printing when selecting your pallet size. Usually, after someone wears the thing you printed, it looks great anyway.

- If you put too much spray adhesive down, it is harder to pull the shirt off the pallet, and the image on the shirt can be distorted. Too much adhesive can also leave a residue on the inside of the shirt, but this washes off easily.

- After printing a lot, you may notice a fuzzy build-up on your pallet that can lead to bumpy prints. This hairy monster can be removed by applying paint thinner or lacquer thinner to the pallet and scraping the mess away.

- If you follow the directions on the ink for curing the shirt, the print shouldn't wash away. Of course, since you don't have crazy robots chemically curing the shirts in a factory for you, yours might not survive the apocalypse like your dad's Todd Rundgren T-shirt.

WHAT YOU NEED:

- your shiny new press
- T-shirts for printing
- T-square
- crummy old inside-out shirts for testing
- spray adhesive
- blow dryer or heat gun

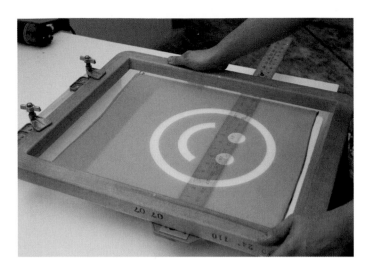

1 Time to print. First things first, place your print-ready 20" x 24" (51cm x 61cm) 110-mesh T-shirt screen in the hinges—but don't tighten them yet! Put a T-square on your pallet to make sure your image is centered and straight. Then hold the screen in place and tighten the hinges.

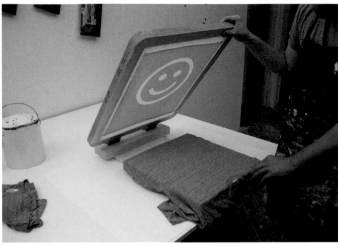

2 Slide a T-shirt on over the pallet as if it were a narrow human body. Keep it straight so it doesn't get twisted and you accidentally print in the armpit.

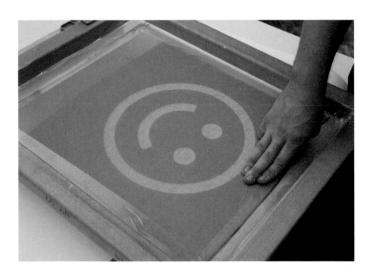

3 Now lower the screen down on top of the T-shirt. This is where you measure how low or how high to print your image on the shirt. We recommend placing your design "three fingers" below the collar. Memorize the placement of the shirt on the palette.

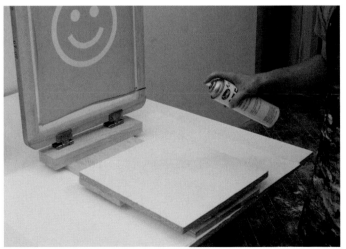

4 Take the shirt off and spray the palette with a light coat of adhesive. (You'll probably have to spray more adhesive every few shirts.)

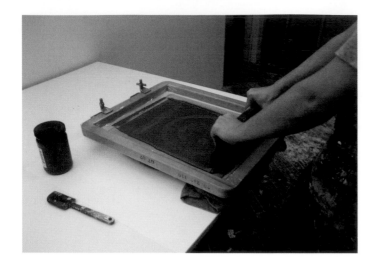

5 Put a shirt on the palette and print like we've taught you. (See pages 57-61.)

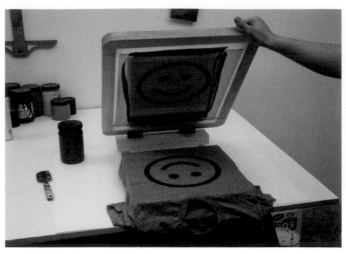

6 Lift your screen up, and bask in the magic of it all.

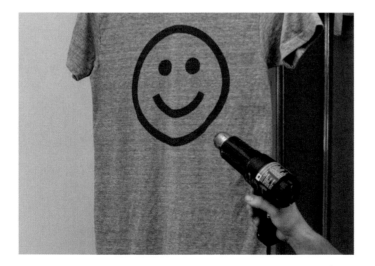

7 The ink will be wet, so be careful when taking the shirt off the pallet. Don't worry about any remaining spray adhesive inside the shirt—it will wash off. Hang or place your shirt(s) to dry in a safe area. Most water-based inks will air dry. It's good to semicure the ink with a blow dryer or heat gun and then throw the shirts in a laundry dryer to make the image last.

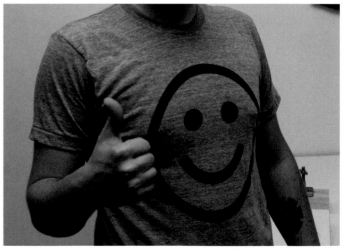

8 Aren't you pretty!

RECLAIMING A SCREEN

Screens can be reused over and over with different images burned on them. All you have to do is try to get your screen back to the state it was in when you first got it: clean and clear. To do this, you must use toxic chemicals to melt away the emulsion. Don't cry! You can always make that screen again if you want to in the future. All you need to keep is your film positive!

TROUBLESHOOTING

- Work until you just don't think it's possible anymore to get all the emulsion out. Once you try to reclaim and miss some, it somehow turns into concrete and never leaves you alone. Just keep scrubbing and spraying until it seems hopeless.

- You might see a ghost image of the prints you have done before. Look closely to see if there are clogged holes. If not, then don't worry about the ghost; it's just a reminder of prints of the past and shouldn't do you harm.

- If you see a lot of the outline of the old print just around the edges of the screen, and that's the part that's giving you trouble, it means you're not cleaning your screen well enough between prints. Be diligent. Clean your screen better between print runs!

- If you suddenly have emulsion stuck in the screen in places you printed a design a long time ago, you need to stretch a new screen. The screen fibers were worn down by whatever ink you used before (this happens more quickly with harsher inks), and remembers where you used it, and then the emulsion likes to stick there when you're reclaiming. There comes a time for all things to die, and screen mesh has to die, too.

- When your mesh is old and crummy, just get a new piece and restretch it. Good as new! Or buy a new screen.

WHAT YOU NEED:

- particle respirator
- goggles or a splash shield
- rubber gloves that go to your elbows
- strong water spray or power washer
- reclaimer
- spray bottle
- scrub brush
- patience

1 Put on the safety equipment. Please! For your own good, do it! What if you want children? Think about the future.

2 Get the screen wet front and back.

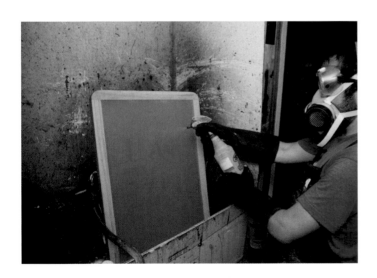

3 Spray reclaimer liberally onto both sides of the screen. Let it sit for thirty seconds.

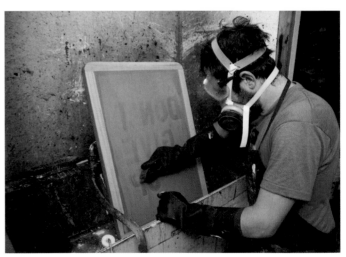

4 Use a scrub brush to scrub both sides of the screen for about one minute. Press firmly but not so firmly you bust through your screen.

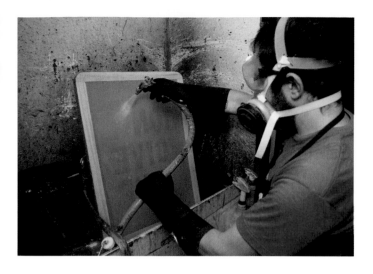

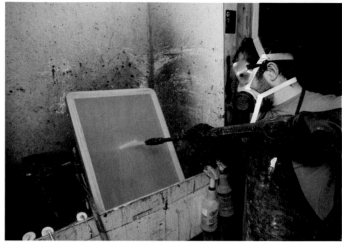

5 You'll notice the emulsion starts to fade. Spray the screen with water thoroughly until all the emulsion looks as if it's gone.

6 If you have one, use a motorized power washer to spray the heck out of the screen. We're talking hard. You have to get every tiny morsel of emulsion off that screen or it will lurk there until the end of time.

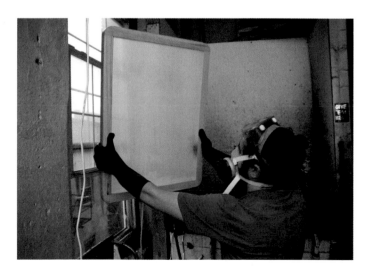

7 Hold that screen up to the light and make sure you got all the emulsion out. Show the world you did it!

PRINT FACT: HISTORY OF THE T-SHIRT

- T-shirts have been included in all American soldiers' uniforms since World War I, when the European troops were spotted staying cool in cotton undershirts while the American boys had a heat freak-out wearing long-sleeved wool.

- The Marines, who began to receive T-shirts as part of their uniform, were getting killed because the white shirts were so easy to spot from far away, so they used coffee to dye the shirts and save themselves.

- Until the 1950s, T-shirts were considered underwear. Then actors began to appear in movies wearing them while playing bad boys, scandalizing everyone. So all the cool kids started wearing them.

- The first printed shirt was printed with a slogan for Thomas Dewey, who was running for president in 1948: "Dew-it with Dewey." Desperate.

- The first T-shirt used by a company as a product advertisement featured a can of Budweiser in the 1960s.

- The T-shirt has become a canvas for freedom of speech and expression. Yet people may never tire of shirts that say stuff like "Are the Orcs following me?" and "Boobies make me smile" and "More Cowbell."

CHAPTER

4

PRINTING ON OBJECTS IN THE WORLD

PRINTING ON OBJECTS IN THE WORLD

You can screen print almost anything. Almost all flat surfaces you can hold a screen to are printable, with varying degrees of success. When determining whether you can print on something, consider the following:

1. Does this thing you want to print have a surface that most of your screen can touch?

Stucco, for example, would be horrible to print on, because the rocky surface would touch the screen only where it protrudes the most. That's the only place your graphic would print, and it would probably tear the screen.

2. Do you have ink that will stick to what you're printing?

Different materials like different inks, so to make sure all your hard work doesn't get washed away with the first laundry cycle or rainstorm, you should take the time to get the right stuff.

In this chapter, we will demonstrate some good, technical, consistent printing techniques, and some "cowboy-style" printing. If you're thinking about starting a business printing saleable merchandise, there's an especially helpful section in this chapter in which we talk about printing on boxes, bags and stickers to help you brand yourself. For people who want to use silkscreen in their art, we'll talk about printing on wood, Masonite panels and canvas, as well as creating repeat patterns to print on wallpaper or fabric yardage.

T-SHIRTS

T-shirts are easily the most popular substrate for screen printing. There are endless events, businesses and friends who want custom-printed T-shirts. It's also awesome to make shirts for yourself that nobody else has and to create unique shirts by printing on already printed T-shirts. Remember what we taught you in chapter three (see pages 76-78).

OTHER CLOTHES

If you're printing on a garment that has already been constructed, it's called spot printing. Printing on other garments is pretty much the same as printing on T-shirts, except you might run into more seams and pleats, which can get messy. If you keep your screen clean and you're on the ball, you can print on any garment.

TROUBLESHOOTING

Here are some things to look out for:

- Not all fabrics are the same. It's much easier to print on cotton than ripstop parachute material. Fabric ink might not want to sit on some double-knit polyester grandma pants you find out there.

- All fabric inks are going to sit on top of the fabric. Though some inks are softer to the touch than others (water-based inks, for example), you can sometimes run into an unpleasant plasticky feeling to the cloth. This happens especially when you're printing white, or something that has a lot of white in it (if you're printing colors on black, for example).

- If you want your print to permanently and chemically bond into the fibers and be part of the fabric, you have to print with dye suspended in a sodium alginate base, which we aren't getting into in this book.

- If you print on a pleat, seam or fold and then move the screen to print again, you should rub the surplus ink off the back of the screen that squeezed out into that crevice. Otherwise you'll get a big mess when you try to print again.

- A helpful item to have on hand for spot printing is a soft pallet. This type of pallet can easily be made by stretching a couple of layers of quilt batting and smooth fabric, such as muslin, over a piece of plywood and stapling it with a staple gun on the back. Fold the corners as you would wrapping paper and stretch the fabric taut. The soft surface is great for pinning garments in place with T-pins during the printing process. If you want to print on pant legs or sleeves a lot, you should consider making a long, skinny soft pallet that looks like an ironing board. You can stick these pallets inside long tubular parts of the garment and print them flat, which can be hard to achieve otherwise.

BOXES

Printing your logo on the boxes that will serve as packaging for your goods is a great way to keep your name in people's minds. It really makes you look like a pro, and people will be more likely to assume you're legit. Plus, to make money, you can print on boxes for other people.

WHAT YOU NEED TO PRINT ON BOXES:

- flattened box
- blue painter's tape or masking tape
- film positive
- craft or butcher paper
- black permanent marker
- your usual printing stuff: ink, squeegee, screen

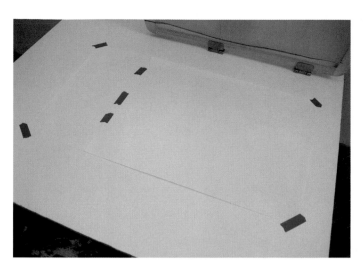

1 Tape paper all over your printing table, creating a covered surface large enough to lie under the whole box.

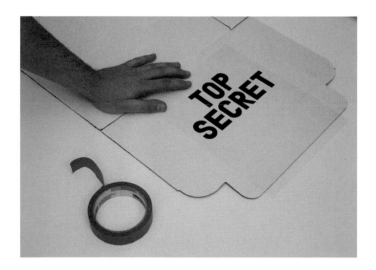

2 Tape the transparency to the unfolded box where you want it to print.

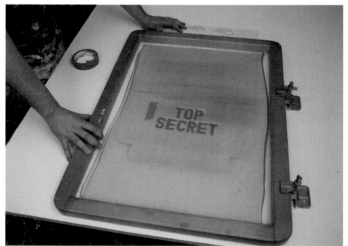

3 Slide the box under the screen and register the taped transparency to the prepared screen. (See pages 52-56 for step-by-step instructions on shooting the screen.)

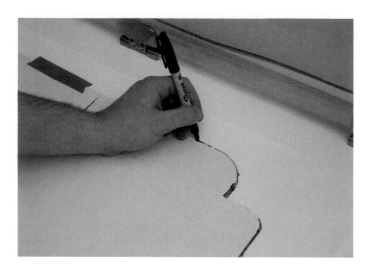

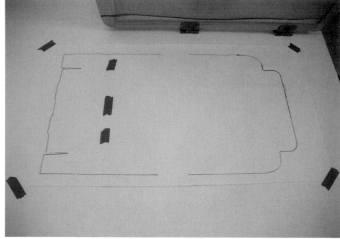

4 Lift the screen and tape the box down without moving it out of registration. Using a black permanent marker, trace all around the box onto the paper underneath it. This will be how you register all the boxes for printing.

5 Take off this first box and register all the boxes to come with this outline. Then print them one by one.

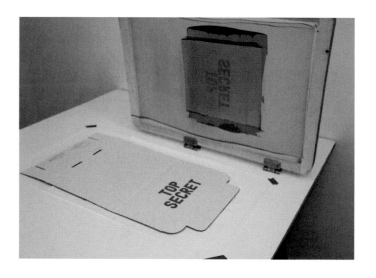

6 You can do as many colors as you want by registering them the same way.

7 Now fold the box and put secret objects in it.

SHOPPING BAGS

Depending on whether they are flat or have handles or are coated with shiny paint, shopping bags can be difficult to print. The flattest, plain paper ones are easiest to print. Other ones can be really bumpy and lead to misprints. Try to get the flat ones. Printing multiple colors can be challenging because, often, bags aren't made exactly the same size, even if they look the same. This makes it hard to consistently register them.

STICKERS

You already know how to print posters to help out a band, but for the whole package you can print on CDs, books and stickers. Printing on these synthetic materials can require different inks, so be sure you read through each section before you go at it. Specialized inks are available through screen-printing supply stores and online stores.

The sticker material that feels plastic, such as a bumper sticker, must be printed with a vinyl ink if you want it to last more than a month. Vinyl ink requires using a solvent to wash the ink out of the screen. Water will do absolutely nothing to this ink. You can slow the ink from drying in the screen by cutting it with some acetone or ink retarder. Stickers made out of paper, such as mailing labels, can be printed with your normal water-based ink. You can order blank vinyl stickers on the Internet or get them at an office-supply store.

Vinyl ink dries very quickly in your screen, so if you don't want to clog every hole in your mesh, be sure you never let the ink just sit in the screen and begin to dry. Always wash out the screen very thoroughly.

TROUBLESHOOTING

- Print in a well-ventilated area or you'll pass out.

- Some sticker paper comes in big sheets so you can print a bunch of stickers at the same time on one sheet. Take into account how you'll cut the sheets so you have even margins on all sides.

- Print straight so the stickers are easy to cut.

- You can cut with a guillotine if there is one around (try a printmaking department at an art school, or a book maker), or a craft knife and a ruler.

- Print lightning-fast or your vinyl ink will dry in the screen and never come out. Seriously.

CDS

Printing on CDs and CD cases isn't necessarily the very first thing you should try, but it can be done in your studio, too. The real commercial CD printers use UV ink, which has to be heat-set. Water-based inks will work, but the image will scratch off easily unless you spray an acrylic clear coat on the CDs after you're finished printing. You can also use solvent-based multipurpose plastic or vinyl ink to print on CDs to avoid scratching and peeling. This means you have to have a solvent to clean the screen (not just water), and the screen will clog very quickly. Again, you can slow the ink from drying in the screen by cutting it with some acetone or ink retarder. You can buy silkscreenable blank CDs on the Internet or at a local office-supply store.

TROUBLESHOOTING

- Test the ink to make sure it prints well, or take it to a screen-printing ink supplier and have them test it and order what you need.

- Before printing, lay paper down on the print table so the CD doesn't get scratched.

- Leave yourself a margin. You don't want your print to be too close to the hole in the center or to the outer edge.

- Make a jig to securely hold the CD. Otherwise it will slide all over the place.

- Be sure you let the CDs dry for a long time (at least overnight) before you package or stack them. Make sure they're not tacky at all before you do anything with them.

CD BOXES OR CASES

You can buy unglued cardboard CD boxes on the Internet or at a computer store. You have to use your imagination to figure out how to align your print to print all four sides at once for the box, but folding up a model will help you. You can also do paper prints for the inserts inside of jewel cases. There are nice cardboard flat sheets that fold up into CD cases available online. Check our resource section (see page 140) for Web addresses.

BOOKS AND OTHER THICK OBJECTS

Books and other thick objects must be set into a jig so your squeegee does not end up ripping the screen when it runs off the corners of the book. You'll have to custom make this jig to accommodate the size of your book. You can shim the screen up with a piece of wood under the hinges and at the end of the screen.

If you want to print only one book, one color, you can probably get away with just placing the screen on the book and gently printing it. If you're doing a big production, you better make a jig so you don't rip your screen.

WHAT YOU NEED:

- foamcore or cardboard to stack into structures
- spray adhesive or tape
- craft knife
- your usual printing stuff: ink, squeegee, screen

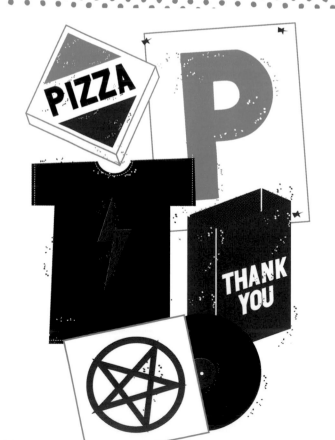

1 Build up layers of foamcore or cardboard to about the height of your book to make a jig for the book placement. Adhere the layers with spray adhesive or tape to make sure they stay stacked together.

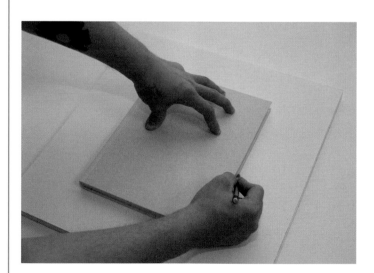

2 Cut down the foamcore to a size significantly larger than the entire area of the screen you will be printing with, including space for pulling the squeegee.

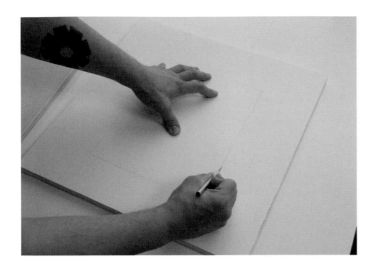

3 Trace the book in the middle of the foamcore. Cut it out with a craft knife. This is your jig!

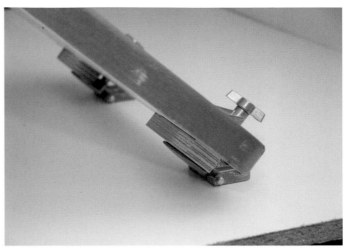

4 Put a block of wood, a stack of paper or more foamcore under the screen in the clamp at the hinge. Bring it up to the same level as your print.

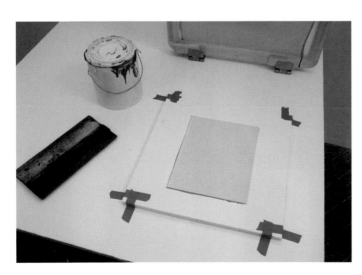

5 Register it as you registered the paper prints you've done before. (See pages 58-59 for step-by-step instructions on registering prints.)

6 Admire your printed book. She's a real beauty.

CANVAS

If you're printing on canvas for a painting, which presumably you're not going to wash, it doesn't matter what kind of ink you use. Canvas is easily printed with fabric ink, but you can print with paint or water-based ink as well. Your choices are printing the canvas when it is flat, stretched and pinned on a soft printing pallet, or printing it while it's stretched on stretchers with some kind of insert inside the frame to keep the canvas from bowing down when you're printing it. We recommend printing the canvas flat because it gives you more control, and because you have a choice of which of your prints you stretch on stretcher bars. If you print the already-stretched canvas, you are a gangster and the world is yours. Tote bags are made of canvas, too, and you can print on them with fabric ink.

TROUBLESHOOTING

- Canvas soaks ink up, so you should do a lot of passes to get the color you want. Be sure to do a test strip to find out the number of passes you will need to adequately print on your canvas.

- It is harder to print fine lines on canvas because it is such a textured surface, so keep that in mind when you're planning your film positive.

- Using a round-tip squeegee is helpful for printing on canvas because it squishes a lot more ink through the holes of the mesh.

MASONITE OR WOOD PANELS

Printing on Masonite and wood should be approached almost like printing on paper—you can think of it as really thick paper. You can print on wood with water-based inks, but then it's a good idea to spray it with a clear varnish if the piece will be going out into the elements.

If you have super-thin wood, you probably don't have to shim it up. If it's thicker, treat it as you would treat a book print (see pages 90–91). Again, if you're just doing one print, you don't have to make a whole jig, but if you're printing a bunch, you should make one so you don't destroy your screen.

METAL, GLASS, PLASTIC, ETC.

Printing on any of these materials requires special inks. Glass and metal need to be printed with enamel inks that are super-toxic and not so great to use at home, unless your work space is really well ventilated and you wear a respirator. As you know, plastics must be printed with vinyl ink, another ink with which you don't want to get too intimate. You also don't want to let these inks sit in your screen long because they will stick and never come out. One alternative is using water-based ink and clear-coating it with something so it doesn't scratch, but this might not work in all applications.

WALLS

Printing on walls and other vertical surfaces can be tricky, and you only have one shot to get it right. But it's a rockstar move that will impress everyone who sees you do it. Water-based ink is the easiest to use, but if you're printing on the wall you can print with house paint if you quickly wash it out of your screen afterward.

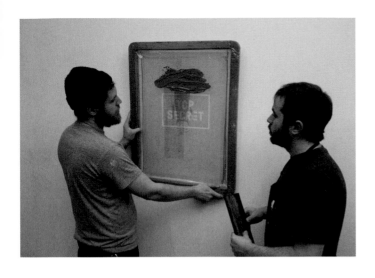

1 Have a friend firmly hold the screen up to the wall.

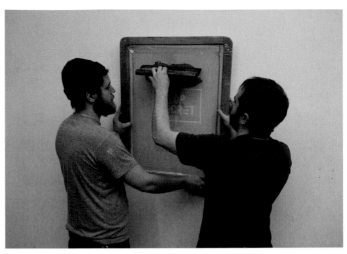

2 Flood the screen with ink.

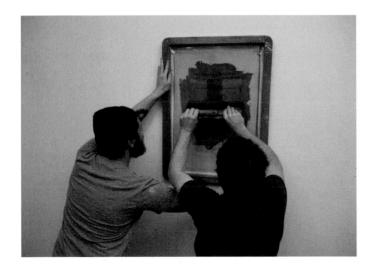

3 You and the friend pull the screen off the wall at the same time, using an orchestration of yelling and signaling.

4 Have a good plan for where you are headed to clean your screen. Source this location before you print.

PRINT FACT: BARREL PRINTING

Special print substrates sometimes require special machines to print on them. Consider, for example, the challenge of printing on a tube. It doesn't seem to jive: Flat screen, curved surface, limited surface area contact—but screen printers find a way.

Pennzoil needs its logo screen printed on its oil barrels. A machine has been made to hold seven empty barrels on rollers in a track. Hydraulic pumps lift the barrel that has reached the middle of the machine up to the level of the screen. Then it rolls slowly in place. As it rolls, a sensor recognizes the welded seam on the barrel and registers the screen to it. The screen moves over the barrel as the barrel turns, and the squeegee pushes ink through the screen only where the barrel is touching it. To register the other colors, the sensor lines the next screens up with the same welded seam the first screen is registered to.

The machine can be operated by people, or it can be turned on with a remote control to print barrels in robot mode. After the barrels are printed, they roll down the machine, and then go off on a conveyor belt to be sent away and filled with oil. These barrels of oil may someday be used to fill the tank of the president's stretch Hummer!

HANG
IN
THE

ONE-TERM
PRESIDENT

PRINT LIBERATION

CHAPTER

5

SCREEN PRINTING
AS BUSINESS / ART

SCREEN PRINTING AS ART

Screen printing as a tradable skill knows no boundaries. You can be hired to print at a shop. You can take on independent and freelance jobs out of your new print studio. You can use screen printing as a medium for your artwork. We hope you will realize all your dreams through screen printing. We have found that if you have a vision and the necessary skills, it is possible to make a living from printing.

Screen printing has significantly altered how the art world and the general public determine what is and isn't art. In the 1960s, artists such as Andy Warhol, Robert Rauschenberg and Ed Ruscha began using what was seen as an exclusively commercial process to create works of art. The screen-printing process was appealing to Warhol because of its directness and its associations with the world of advertising. The medium brought a product-like appearance to the images he created, further emphasizing the ideas behind his work and the Pop Art movement. These ideas include questioning the validity of uniqueness, celebrity and consumer culture.

Screen printing wasn't really acknowledged as an art medium until the middle of the twentieth century. Screen prints were not considered prints because they were not created using plates, and they were not considered paintings because they were created in multiple. Now screen prints have the best of both worlds, being widely used in the print, graphic-design world, and also being given space in prominent galleries and museums. Warhol and other artists who have embraced the medium had everything to do with this massive sea change in the perception of screen printing.

Editions of screen prints are purchased one by one by collectors, museums and average people alike. Prices range depending on the amount of colors used in the print, and the notoriety of the artist or gallery selling the work. Some things that begin as screen-printed graphic design end up in art galleries, such as really good concert posters, wallpaper and even T-shirts.

THE ARTIST'S LIFE

There isn't a surefire way to pursue a career as an artist. It's every man and woman for him- or herself. However, there are many good practices and good resources out there to help you along your path to glory. First of all, there is no substitute for a strong will and a passion for making things. Beyond those two fundamentals, here are some other things that can help you.

Virgil Marti *Bulliy Wallpaper* (screen-printed wallpaper)

opposite page
Eva Wylie *Skydivers* (detail) screen print on paper, fabric

Paul Coors *Are we long for this world?* (detail) screen print on polystyrene

opposite page
Luren Jenison *Hunting Cloth* (detail) screen print on fabric | **Seripop** *Gig Poster* screen print on paper

SETTING UP A STUDIO

Set up a studio where you can go to work only on your art. This will free you from the constant pressures of the real world (for example, washing your dishes, paying your bills, surfing YouTube). It will also lead you on your way to having a good studio practice, which means establishing some kind of routine for when you work on your art.

Setting up a studio is a very personal matter, and there is no right or wrong way to do it. However, following are a few guidelines to keep in mind as you create your space.

- If your studio is not in your house, make sure it's somewhere you can get to easily and often. This way you won't slack off.

- Besides setting up your screen-printing area, you might want some other equipment in your studio. Consider investing in a used (or new) flat file as storage for your paper and for your completed prints. This will save you the shame of hanging a crunched-up print with boot prints all over it at the next show you're invited to participate in. Unless you're into that.

- Have a camera in the studio to document your process. Looking back on things when they were just in the beginning stages can be really enlightening.

- Make sure the studio is safe, with locks, and that the roof isn't going to start leaking all over your expensive rag paper. Get renter's insurance: It's cheap and you can insure your prints. Just do it!

ARCHIVAL CONSIDERATIONS

So this is kind of more big-league stuff, but some inks are more likely to last into the future than others. This might not matter at all to you. But some people don't know different art materials have different life spans. For example, a ton of post-Impressionist paintings are falling apart in the storage vaults of the Museum of Modern Art (MOMA) because they are painted with house paint, which does not stick to canvas for a long time. If you are on your way to becoming a collected artist (you want people to buy your work and keep it), and you don't want your prints to fall apart in somebody's living room in two years, spend the extra money and buy the proper materials.

If you want your prints to last, there are a few simple things you can do:

- Print on cotton rag paper, or another archival paper you can get from an art supply store. Make sure it is nonacidic. Don't expect newsprint to last even for a few months—it is a short-term substrate and is pretty much guaranteed to disintegrate.

- Print using oil-based inks. Historically, oil-based inks are more colorful and more stable over time. Of course, they are stinkier to print with and more carcinogenic, too.

- Store your prints properly. Separate them with glassine or another archival paper in a flat file in a stable environment. Avoid humidity, places with leaks, rusty flat files and places where toddlers crawl around.

- Take your work seriously! You do it for a reason, so protect it. Be sure to transport it carefully when you are taking it to a show.

GETTING YOUR WORK OUT THERE

There are lots of ways to show people your work. It's good to know what other people are doing. Go out to openings. Find artists you like. See where they do shows. Find galleries that appeal to you or that show work that interests you. Talk to the people who curate those galleries. You don't have to be sleazy or anything, but talking to people is the best way to find out what is going on and to figure out how you fit into it. We're all in this world together. We all know each other. It is much easier for someone to remember you when you talk to that person face to face, and when you come into the gallery and show him or her your work face to face.

Most of the guidelines for getting your work out there are pretty common sense, but it helps to see things spelled out clearly. Following is what we've learned through trial and error. We hope it helps you get set and go.

- Be sure you have your work well documented. Hire a photographer or trade work with one of your freelance photographer friends to take some good, well-lit slides of your work. Get digital images at a high resolution. Get old-fashioned slides if you want. (You can always get slides printed from digital files, even overnight at some Web sites.) Keep the images organized, with dates, materials and all the information you think you would ever need to make a slide sheet on the spot.

- Once you find some galleries you are interested in, see if they do any juried shows. See if you can submit slides or ask the gallerist for a studio visit. This is when the people who curate the work in the shows come out and see what you work on, in your environment. They are great at giving critiques, and knowing that they'll come to visit you will motivate you to have a good studio practice. And if they like you, they'll probably stay in contact with you.

- Slide registries are collections of images accessible to gallerists and curators. There are many slide registries, and some are juried. Apply with your digital slides. It isn't the same as shoving your slide sheet in someone's face, but people do peruse them, and you never know who might see your work.

- Know that if you approach a gallery to represent you, it means you can't sell your own work without going through them. This means even your roommate needs to buy your work through the gallery. It's a trust situation, and you have to be honest.

- Show only the work you think is the most successful and of which you are most proud.

CREATING AN ARTIST'S WEB SITE

Another contemporary way of getting your work out there is to have a good artist's Web site for yourself. Everybody who's anybody is online anymore, so you might as well join the party.

However, if you're going to take the online plunge, you should make sure to do it right. Here are some helpful tips to make your first Internet foray a success.

- Hire a graphic designer or trade prints with somebody you know who creates Web sites and can take your creative input.

- Find some other artists' Web sites you like, and figure out what appeals to you about the structure or the aesthetic.

- Make sketches of what you want the homepage and the pages leading off the homepage to look like.

- Figure out how to break down your work, whether by medium, time period, concept or another differentiating factor. This helps the Web designer figure out how to structure your page.

- Be sure you get it the way you want to present yourself. Make it easy to navigate. Have a way for viewers to contact you via the Web site.

- Having a résumé on your Web site is optional. Another option is having a résumé available on request.

Also, if you want your work up on the Internet but you're not quite at the point where you can have a designer make you a page, there are plenty of hosting places online where you can put up images of your work and people can link to them. Some of the potential host sites are listed in the resources section for your reference (see page 140).

Space 1026 Philadelphia, PA

APRIL FOOLS

ALLEY CAT

opposite page
Print Liberation *Reload Bags April Fools Race* screen print on paper

Print Liberation *Black Floor Gallery* screen-printed T-shirt

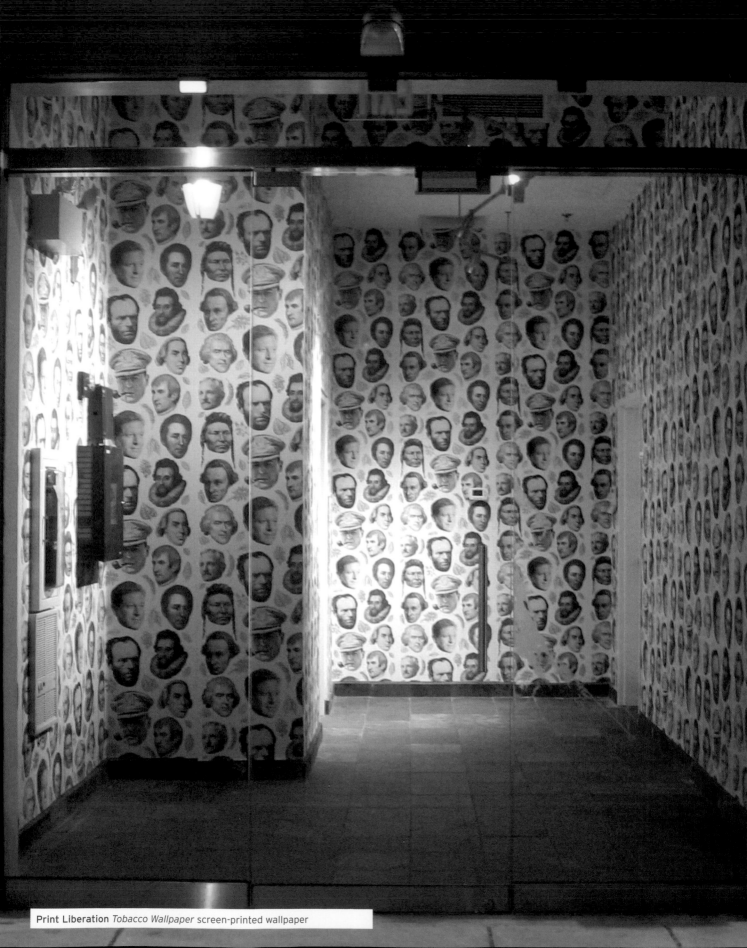

Print Liberation *Tobacco Wallpaper* screen-printed wallpaper

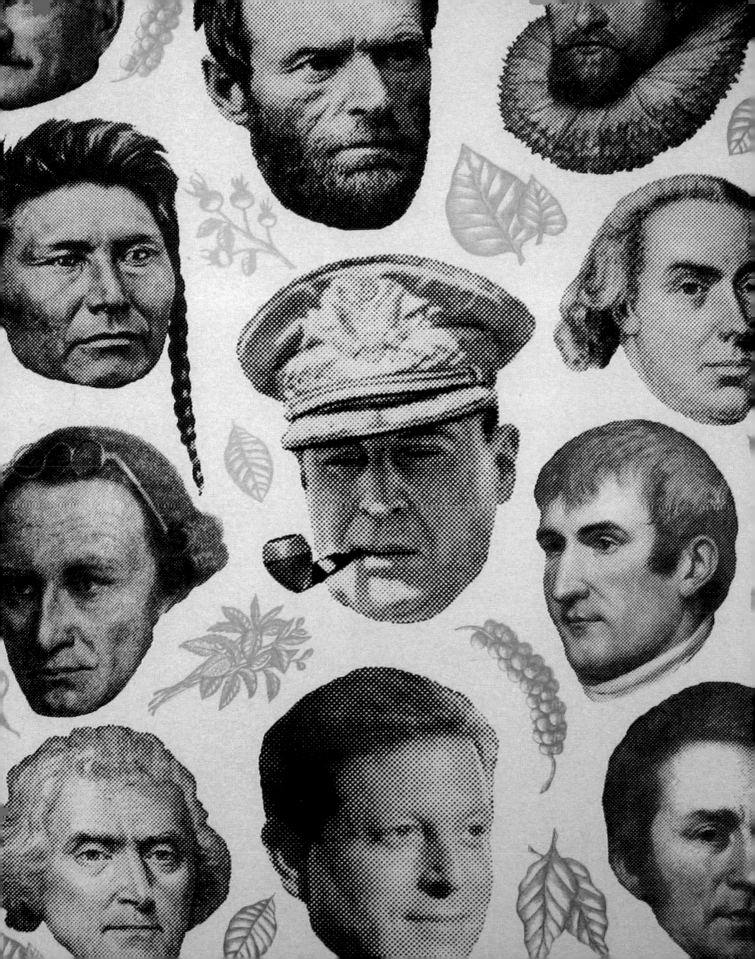

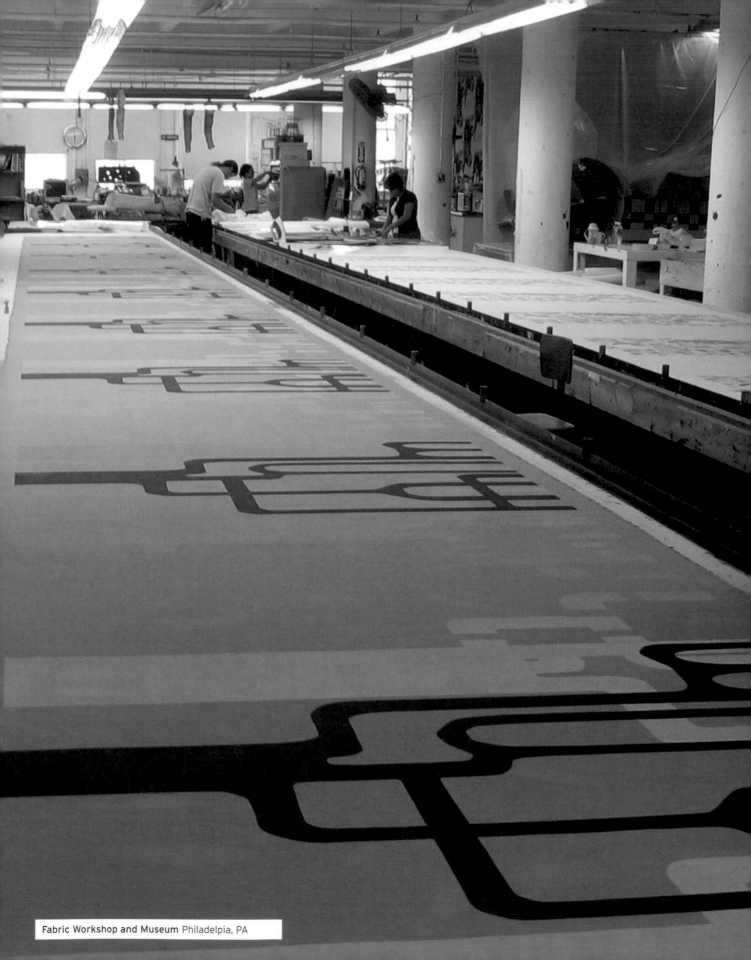

Fabric Workshop and Museum Philadelpia, PA

ARTIST RESOURCES

Many organizations out there exist solely to benefit people who want to make art. They provide residencies with free studios, studio visits with artists and printing facilities. They also connect artists with other resources.

Alliance of Artists Communities
www.artistcommunities.org
This research site for artist communities, residencies and retreats features a database of artist co-ops and live/work spaces regionally and by state.

American Print Alliance
www.printalliance.org/index.html
The American Print Alliance is a nonprofit consortium of printmakers' councils. It has a directory of print dealers and schools, as well as private and museum collections. Use this directory to find galleries and museums that buy lots of prints and do print shows.

California Arts Council
www.cac.ca.gov
This state-funded council houses a slide registry, lists periodic updates of residency and grant opportunities, and elucidates grants and other funding opportunities.

California Society of Printmakers
www.caprintmakers.org
Lists of national and western United States resources, including research arts councils, studio visits and print-making-centered events in California are available here.

Fabric Workshop and Museum (FWM)
www.fabricworkshopandmuseum.org
This organization is a Philadelphia-based nonprofit with a permanent collection showcasing amazing artists who have worked collaboratively with the FWM since its inception in the 1970s. They offer a great apprentice program. There are also always big artists coming through working on large-scale loosely textile-based projects with the knowledgeable staff and technicians. This resource alone is worth coming to Philly for.

Headlands
www.headlands.org
International multimedia artists apply to live and work with artists of other disciplines, have frequent studio visits and develop a body of work for review during one- to six-month residencies at Headlands.

Kala Art Institute
www.kala.org
You can apply for Artist-in-Residence status at this Berkeley, California, based print studio and electronic-media center. It also grants annual fellowships.

Lower East Side Print Shop
www.printshop.org
This is a great resource to New Yorkers, as anyone can go there and rent printing space. It also houses a huge collection of prints that draws collectors and teaches classes on screen printing and other printmaking methods.

New York Foundation for the Arts (NYFA)
www.nyfa.org
NYFA is a really helpful organization that connects you with all kinds of residencies, grants and fellowships for your medium or niche. It's like a dating service to foster relationships between you and money. You tell it you're a twenty-four-year-old female with one-eighth Native American heritage, and it pops up with the Women Printmakers of Native American Heritage Trust Grant. I mean, it takes a little more work than that, but it's a great resource. It's not just for New York, but there are more listings from the Northeast than anywhere else.

Ox-Bow
www.ox-bow.org
Ox-Bow is an international residency program with visiting artists and challenging studio visits outside of Chicago.

The Pew Charitable Trusts
www.pewtrusts.org and www.pewarts.org
The Pew gives to a lot of different grants and manages a lot of trusts. There's always something going on there. It also gives out a big fellowship of fifty thousand dollars to a few Philadelphia-based artists every year.

Printmaking Department at Middle Tennessee State University
www.mtsu.edu/~art/printmaking/print_links.html
Strangely, this university printmaking department's Web site has a really thorough index of printmaking schools, grants and fellowships; museums and galleries; and more.

Res Artis
www.resartis.org
Res Artis is a worldwide residency database for all media, including visual arts, and specifically printmaking.

18th Street Arts Center
www.18thstreet.org
The 18th Street Arts Center grants residencies and gallery programs for Los Angeles-based artists.

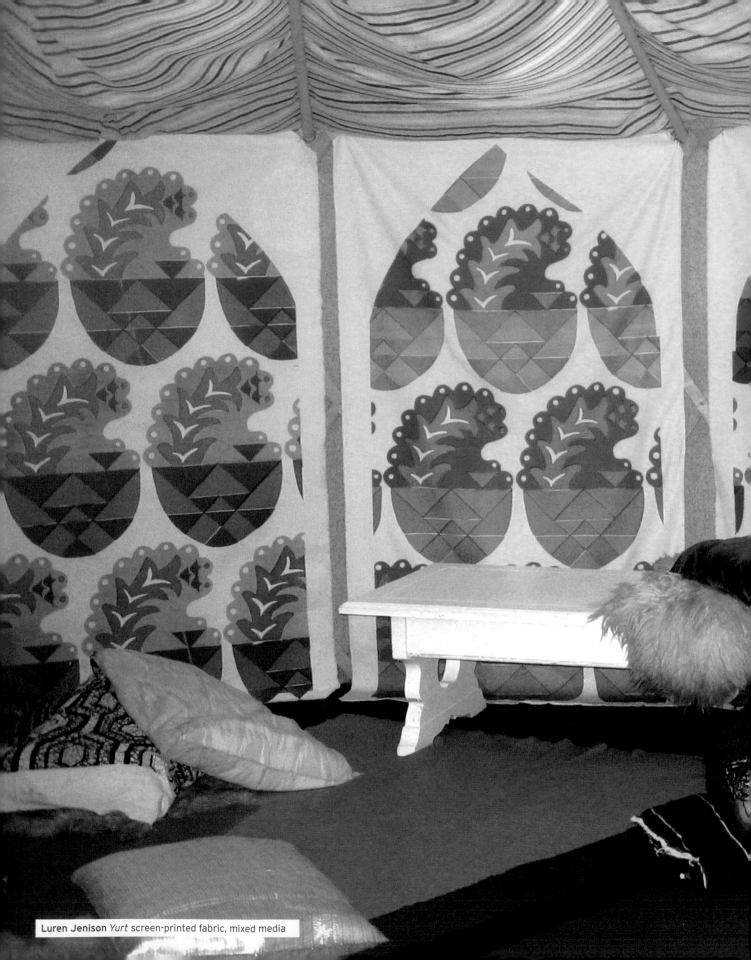

Luren Jenison *Yurt* screen-printed fabric, mixed media

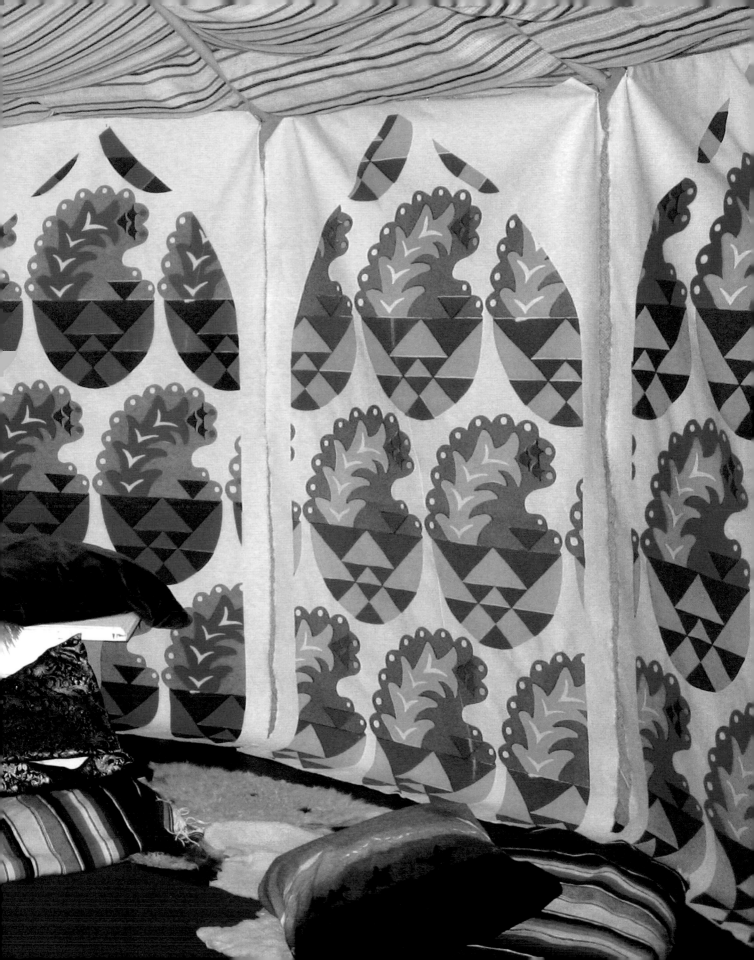

SCREEN PRINTING AS BUSINESS

Many of the same principles for getting your work into the world as a fine artist apply to getting started as a professional printer. But the rules do change. This is a cut-and-dried business. You can build up your business one job at a time, and soon you will get attention and people will start hiring you. Maintain a good reputation, a high-quality product and an aggressive strategy, and you will be a business person in no time at all.

Don't burn bridges. In every area of your life someone needs a printmaker, so don't count anyone out. Even screen printers need other screen printers once in a while. You'll find the world gets smaller and smaller as you get more and more specialized, and the screen printer's world is like a little incestuous family. Every printer knows someone who knows how to get the overstock ink from a supply store or has a hookup at American Apparel or has one too many wedding invitation jobs this week. You help each other out.

GETTING STARTED

CREATING AN IDENTITY
Make a name for your company and figure out how to brand yourself. That means making your company name or logo recognizable in your city or on the Web. Take the time to think of a catchy name, such as Print Liberation, and put your design skills to their fullest working on the logo. Or if you're better at printing than designing, get a local graphic designer to team up with you and offer to do some prints in exchange for a good logo. Work to get what you want.

Then print it on everything—posters, postcards, stickers, T-shirts, business cards, eye patches, temporary tattoos, babies. Whatever! Just get the word out that you can print on things and that you want people to contact you.

PROFICIENCY
Make sure you are good at printing and can really, truly offer great services for hire. This means no sloppy prints, no missing deadlines, no under printing. Just you, making good prints when people want them.

Start small. You probably don't have a heap of gold hidden behind your photo emulsion. You probably can't buy twenty thousand shirts up front. Start by doing the jobs you can handle, and eventually work up to the big jobs that may even require more equipment that you'll have to get somewhere down the line. Ask for half the money up front on jobs in the beginning. That way you can buy the supplies you need to print the project.

WORD OF MOUTH
Do some jobs for friends. Do some jobs for free. These jobs, especially the ones in which you have a lot of creative freedom, are just the kind you need to build your portfolio. Then you will have a more concrete base of projects to show to potential clients.

While you are building a professional portfolio, you should keep a few things in mind. If you're smart about your work, you can use what you've already done to generate more work.

- Document these projects well. Photograph the final prints in a clean, professional way that communicates the project in your style. You may want to hire a photographer to help you with lighting. Get digital images at a high resolution. You can put these on your Web site later.

- Make sure your client, even if it is your friend, is satisfied with the end product. You want your friends to think you do good work so they can spread the word.

- Don't get swamped with work you're doing for cheap. Just do a few projects here and there in the beginning. You need to make money, too—not that you're going to forget that.

- If you have really hard-networking friends, give them some of your business cards, in case they meet someone who needs screen printing.

- Leave your business cards in the right hands. If you want to do concert posters, send an informational packet to a concert promoter or a concert venue. Send packets out to bands you like. Be creative and think about unusual people who need you to screen print things for them.

Thom Lessner *Paul Green School of Rock* screen print on paper

CREATING A WEB PRESENCE

We are burning into the future. The World Wide Web is the place to be. You can show off what you have been printing, and you can even sell it online. There are tons of Web-savvy people out there who are as eager to build Web sites as you are to screen print. You can trade your work for their skills or work out something between yourselves, payment-wise.

Find Web sites with good structures that you like. Make notes about what you like and then begin to create a rough outline of the structure you'd like for your Web site. When you're working with your Web designer, be sure he or she can do things such as make a shopping cart, break up your Web site into different sections and design in the aesthetic you want. Make sure you are able to update the Web site from the back end so you can put up your new work and manage the site after the initial setup.

Send out e-mail blasts to people you know, people you meet through your networking and chatting, and people who email you for information about your company. E-mail blasts are basically big batch e-mails that have some kind of "card" or update about what you're doing, what you want to be doing and an invitation to come check out the Web site or contact you to talk about doing a job. Note: It's good to put the e-mail addresses in the blind carbon copy (BCC) section of the email so you don't show everyone what's up your sleeve. Don't be tacky.

DECIDE WHAT YOU'RE WORTH

Once you get going, you'll have to figure out how much to charge people. This is a personal topic, so we're only offering rough guidelines. Be sure you always talk about money at the beginning of a job, unless it's a super-amazing project you would do for free. When you submit a quote to a client, ask the client to initial it so you have a record that he or she agreed to pay that price.

- Most printers charge "x" amount per print, which increases with more colors—for instance, $1.00 for the first color, and $0.50 for each additional color.

- You can charge a "setup" charge for each screen used, which covers burning the screen and includes the Mylar cost. This can be between fifteen and twenty-five dollars for poster-sized screens, or way more if it's a big dog.

- Always factor into your materials costs a few extra of whatever you're printing on. You will make mistakes. It's natural.

- Charge for anything you design. Designing takes time. And it's a valuable skill. Charge by the hour for design work.

- Make sure the client's artwork is printable. If you have to alter the original artwork to make it printable, be sure you charge by the hour for those corrections.

As a side note in this section, keep an eye on what jobs you're taking once you get more successful. You don't want to take a bunch of crappy jobs you're not going to be proud of. You won't want to put them in your portfolio, and you won't want to work on them. Don't be too picky, but just keep taking the pulse on your business and make sure you're taking a majority of jobs that excite you. Maintain your good image and reputation, however, by doing a 100 percent great job on whatever jobs you do take. Finish the jobs on time, and give every client what you promised.

SUSTAINABILITY AND GROWTH

Know when to grow. You might get to the point where you can't handle the amount of jobs you're getting with the number of people you employ or the type of equipment you have. Figure out a way to invest in your future. Hire another printer. Buy a faster, better T-shirt press, even if it's secondhand. Job out some of your projects, which means hiring other printers to print your jobs for you. Research what equipment other printers who are a little bigger than you are using and how they're different from you.

Stay aware of what's happening in your business. Step back every once in a while and assess what's in the air. Try to figure out that you need another printer before the first printer gets totally overworked and quits. Be intuitive, as the business is your baby and you know what makes it run smoothly. If you seem like a sane, happy business owner and your employees (if you have them) are happy, people are going to hire you because you have it together. Present a good face, even if things are crazy in real life. The client doesn't need to know everything.

ANDY WARHOL AND THE FACTORY

In 1962, Warhol started making screen prints because, he said, they were "slightly different each time...simple quick and chancy." The month he became obsessed by the medium coincided with Marilyn Monroe's suicide, hence the use of her iconic portrait as his subject of choice. Screen printing became Warhol's favored medium because of its commercial and flat appearance, and because it allowed him to make production art with an "assembly-line effect."

During Warhol's most prolific years, that assembly line was in a studio he called "The Factory." Located in Midtown Manhattan, it was the center of a raucous and dynamic scene all its own. Celebrities and artists came for parties, to hear music and to take in the spectacle. Warhol worked constantly through it and was an attraction in and of himself.

The studio was in constant flux, with different people coming in and out, day and night. Warhol was working on prints and paintings in the studio, but in 1965 he began working on films and videos in the space, filming with director Paul Morrissey, and on his own, the people and things that were happening around him. The regulars became actors, and the movies, though not of the highest technical quality, still force the viewer to watch something for longer than he or she normally would, as well as give special attention to the banal and appreciate humanity, no matter how jaded, zany or drug-addled it appears onscreen.

The doors of The Factory were open to pretty much anyone who came over. This was the policy until 1968, when one of the actors and aspiring screenwriters who was a regular at The Factory came in and shot Warhol in the chest, nearly killing him. Following this incident, Warhol kept a more private studio life and began a different "post-Pop" mode of working, making many of the celebrity screen prints we are familiar with today.

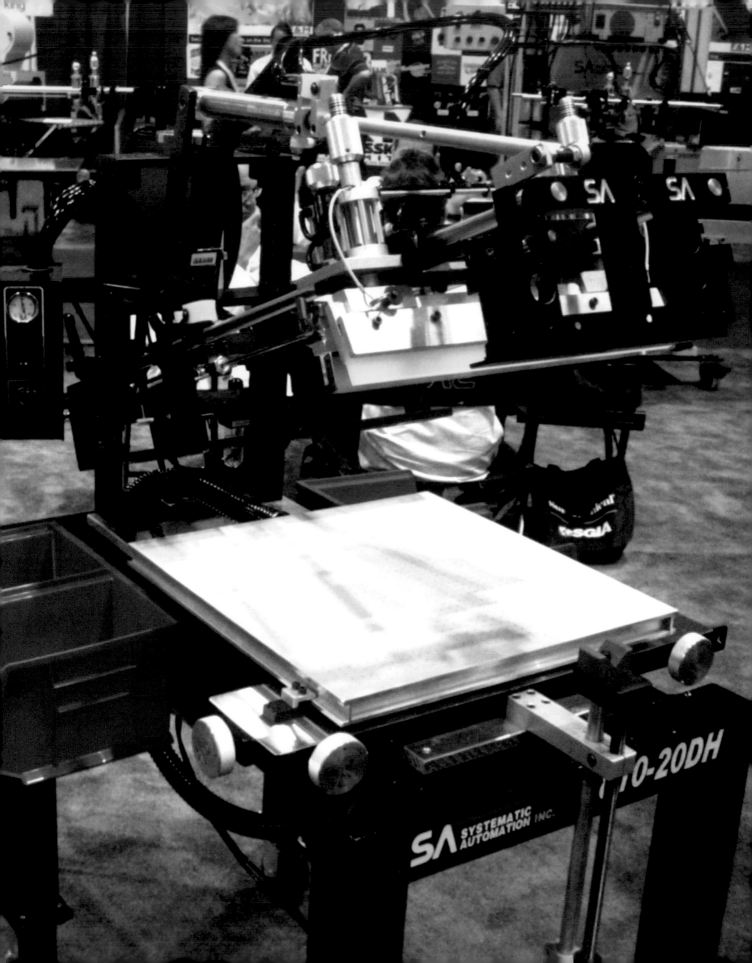

CHAPTER

6

HERE, NOW AND BEYOND

PRINTING NOW AND BEYOND

Screen printing changes as technology progresses and people think of newer, better ways of doing things. Remember the timeline (beginning on page 10)? As more people become screen printers and refine the process, screen printing continues to develop new, more efficient ways of reproducing graphics and images. In big factories, giant sci-fi monster presses with pneumatic arms are used to print hundreds of T-shirts an hour. In little factories, people like us still print with our arms, but that too has become easier and healthier with all the new developments in the industry.

As screen printing develops, so do other printing techniques, such as digital printing. All the technological developments in digital printing have caused some unease in the professional screen-printing world, mostly in big screen-print factories that print huge job quantities on rotary printers. The digital revolution also really impacts small-run printers because printing digitally is often cheaper than screen printing simply because of the nature of the process.

However, digital printing certainly doesn't mean the demise of the screen print. There are many things that can be achieved with screen printing that can't be done with any other printing process.

First and foremost, there is just something magically tactile about a screen print that you can't achieve with digital prints. It's the charm of the handmade. (That can also be your mantra if you mess up a print.) Digital prints can give the feeling that they are being churned out without a thought or care for where they end up, what they're plastered on or how many are thrown away. Screen prints are special. They demand more attention because they look more handmade. Someone took the time to make that poster and hang it up on the telephone pole by your house, so you should look at it for a second. You should know—now that you too have gone through all the preparation, blood, sweat and tears—what it takes to make a big pile of posters.

Screen printing also has a lot of unique technical qualities that other types of printing do not share. You can get powerful, vibrant colors that radiate off a T-shirt or poster. Screen printing deposits more ink onto the substrate than almost any other printing process, so the color can be much more saturated. You can print with all kinds of amazing inks you can't use in other printing processes, including fluorescent, metallic, scented, flocked and

thermochromatic (or Hypercolor). You can print with inks made with glue, clay and electrically conductive metals. You can structurally change a material you print on, as with "burnout" type prints, which chemically erode cotton in a cotton/polyester fabric, or "puff" pigments, which cause a textile to emboss or pucker up where it has been printed. And you can print on just about anything: unfired clay, almost any textile, glass, wood. Your imagination is the limit. Most of all, it's cheap and easy to do yourself. You don't have to rely on a lot of machines—it's pretty much just you, some chemicals and a light.

There aren't that many secrets in the screen-printing world. It's basically an open-source technology, with forums, tribes and groups in every corner of the Internet and real life focusing solely on making it easier for everyone to do. These groups range from low-budget, punk rock activists talking about the best kind of beer to water ink down with, to fiber-artist moms talking about what kind of dish detergent is best used to do a bleach print on tie-dyed silk. There is a huge network of forums dedicated to getting screen-printing gigs and also sharing insider tips on, for example, building a jig for printing CDs. You should exploit all of these places to find the answers to any questions that come up when you get more into printing. It's all based on experience, and, chances are, you'll soon be able to answer other people's questions. This idea leads us into some of the interesting things that are going on in printing right now, and ideas about the future of screen printing.

DO IT YOURSELF

Our generation is not held back by traditional pedagogy and limits of institutional learning. We go out and get knowledge ourselves, and we build our own world from the ground up. By teaching each other and ourselves how to do things, make stuff and build, we have shaped the world around us into a colorful, weird, wonderful place made by young people.

While most of us are computer-wise, we are handcrafting things more and more. Handcrafted objects supplement the increasingly digital structure of our social interactions. For example, most people will find out about a music show via a MySpace bulletin, but special screen-printed cards or posters are made anyway, maybe to make the event, or at least the invitation, more real. With all the digital stimuli out there, the simple act of making something tangible grounds the whirlwind. Concurrently, the aesthetic of a lot of contemporary art is naïve and handmade. Maybe by making something that looks handmade, artists are prompting viewers to remember the act of making things.

Many of the more mainstream elements of the "craft movement" have a nostalgic aesthetic, harking back to sweeter, gentler times, when people still made things by hand with care and tenderness. Most importantly, the products of this movement, no matter what quantity is for sale in the Etsy store, seem to be unique or "one of a kind." Old tell-tale signs of amateur craft, such as stitches showing at seams, wonky corners and childlike shapes have become symbols of this resurgence in handiness. People love it because it's handmade and because they are tired of things looking like they were mass-produced in a factory. People love hand-printed things because they were hand-printed, and not fed off a roll into a machine and churned out by the million.

Knowing how to print things in the home or personal studio isn't just a way into a niche market; it's another tool in an arsenal of ways to not have to rely on other print businesses and corporate franchise printers. By becoming the printer in your friend circle, people can rely on you instead of a stranger to help them create what they need. You have localized the commercial printing activity among the people you know down to just you. This means everyone is keeping the money in a tighter circle. Instead of paying some gigantic corporation an amount that's super expensive to you and pennies to them, you can pay your friend. Then you know where it's going. If your friend is going to be paying somebody to print her band's new record cover, it's better for her to fork over her dough to you than to pay Kinko's.

WAYS TO DIY

- If you have been printing awhile and stumble upon an idea or product that you think people want or need, don't hesitate! Get your act together and make it happen! Your passion is all you've got.

- Make sure you have the ability to make the thing you want or have the means to get someone else to make it for you in the quantities that people may want.

- Drill your successful friends about how they got started finding the market for their product. If none of your friends are entrepreneurs, do a little research. Find someone online or research a brand in a boutique that seems on par with your product or brand, and ask questions. Don't expect people to give you the names and e-mail addresses of all the people who helped them along the way, but get an idea from them of what they did and how they shopped their idea around. Keep in mind that most people work very hard to become successful and they're not going to give it away for free.

- Pool your resources. If you want to sell your products online, make two weeks' worth of cupcakes for your photographer friend, or do a deluxe maid service on your Web-designing ex's apartment as a bribe for helping you set up a site. Do it yourself (with help from other people).

- Remember that just because you put it out there doesn't mean people will stumble across it. Whether you're selling your stuff online, in boutiques or on a card table in your driveway, you have to advertise and market yourself to the people who you think will buy your product. This means setting pamphlets out at the organic food store if you're making crochet dread cozies with handprinted leaf appliqués. It means going to the Fancytown baby store and putting a sample printed floral baby onesie on the cash register with your business card diaper pinned to it. Put yourself in the customers' shoes.

- Plug into what's out there for other DIYers. There are tons of local craft fairs and flea markets around the country. Get to the big city if you can, and rent a table for yourself. Make a virtual store in one of the many online marketplaces for crafters like you. Most likely, your ideas and entrepreneurial attitude will be embraced.

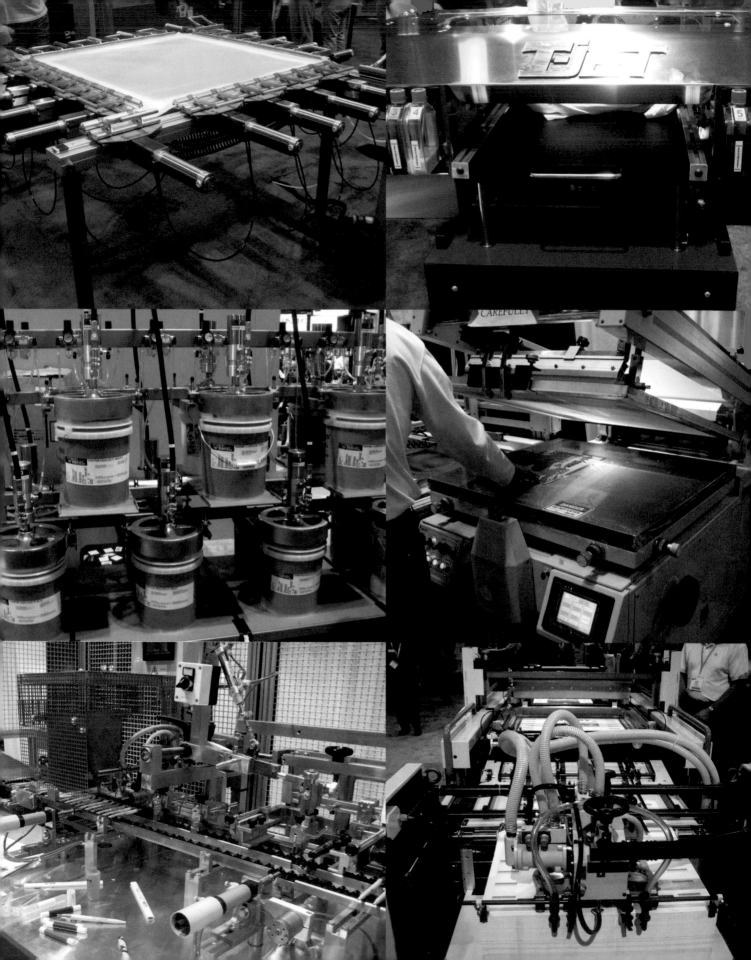

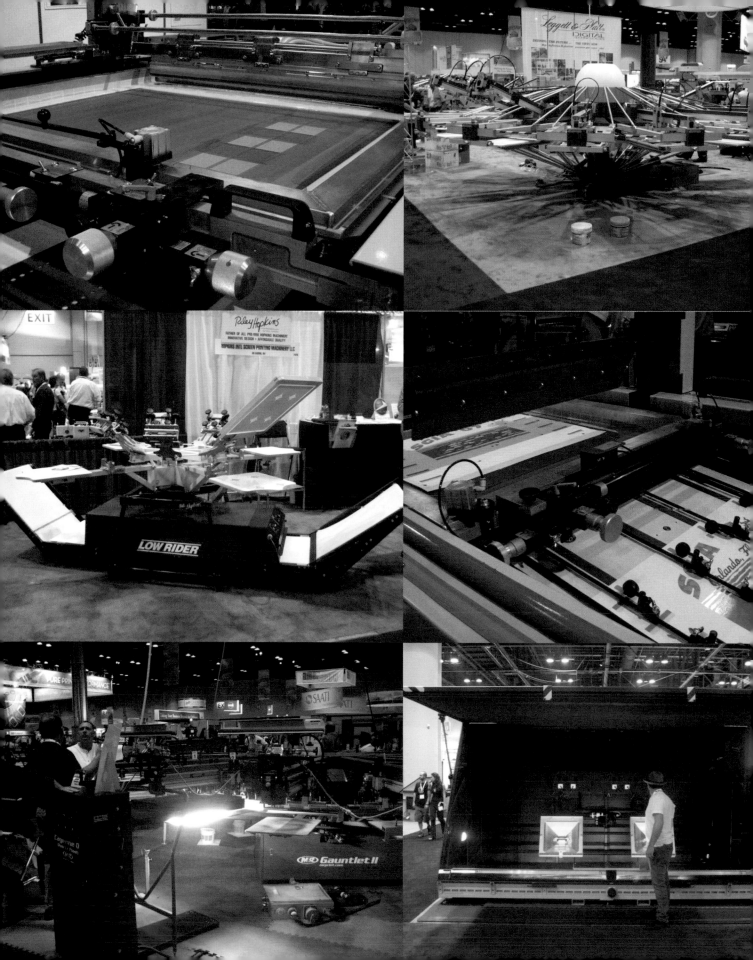

TECHNOLOGICAL DEVELOPMENTS IN PRINTING

Technology is developing at a fast pace on both sides of screen printing: In the print shop and also in screen print's final application in the world. While digital prints get bigger and faster and more colorful, screen print develops as well, maintaining its great archival colors and unique applications and introducing faster and more interesting techniques for every step of the process.

SUPER-FAST, EFFICIENT MACHINES

Screen-shooting machines carry screens through a (big) track to take them from uncoated to ready-to-print without any human contact. This can speed up production in big print factories and reduce inconsistency and costly experimentation. They are seriously the size of an RV.

Screen stretching was a competitive sport in the 1980s, inspiring such a fad for tautness that screen-printing experts eventually declared that the industry had outdone itself by surpassing the point where it would even possibly matter if the screens were any tighter. Now there are big robots with hydraulic clamps to stretch a screen so taut a feather could bounce off it like a basketball.

Cylinder screen-printing presses can screen print paper really fast. A cylinder vacuum pulls the paper down to itself and rolls it while the paper is being printed by a flat screen that moves above it. These presses are often used for printing posters, as well as other paper and light plastics, churning out almost three thousand prints per hour.

Apparently everything can be automated, including moving the tiniest, weirdest objects on printing presses. There are machines out there to do everything from rotating a pen while it is being printed, to stretching a beer cozy on and off a cup during printing, to flipping fanny pack buckles to print both sides. Obviously, these are for the Big Bananas to use in their print factories, but you never know. Someday it could be you!

Giant beasts of T-shirt printing machines roam the earth, looking really sci-fi and making us feel like we're in slow motion when we print by hand. Hydraulic-powered arms whip up and down, spin shirts on a big wheel and even heat-set and fold them before we could even finish taping off the screen.

CRAZY NEW WAYS TO SHOOT SCREENS

Direct-laser-screen shooting is a high-tech, new way to expose screens. Basically, you import your vectorized image into these machines using a CAD program and turn it into machine language. Then a plotting machine (think Etch-a-Sketch) with a laser attached to it for accuracy burns the areas you designated in your design and your screen is ready for washout!

XpressScreen system is new to the market and works like a Thermofax machine or a Print Gocco, flash-burning a piece of screen that's precoated with emulsion against a photocopy, bonding the emulsion to the carbon in the copy. Then the paper of the photocopy is peeled off the screen, with the "positive" or dark areas of the copy peeling off the emulsion on the screen, leaving those areas open. The XpressScreen system has a fresh approach to stretching the screen on a frame: The screen rolls out onto a frame of adhesive cardstock when it is being burned, and then you snap four sides onto the screen to stretch it as taut as you could dream of, with no effort. When your print run is complete, you just unsnap the frame and toss the screen. It comes in a precoated non-light-sensitive roll, and you can just get going on another one without even messing with emulsion.

Another computer-to-screen system uses wax to apply the stencil directly to the screen from a digital file. A big printer reads the file and moves over the screen, depositing precisely the image you import as your positive onto the screen in the form of a wax ink. Then the screen can be exposed to UV light without using glass or a vacuum table because the positive is directly on the screen. When you wash the screen after exposure, the ink washes out. A pretty fool-proof—though prohibitively expensive—way of shooting a screen!

TECHIE DEVELOPMENTS

- **Conductivity:** You might not know that inside all of our laptops, Wii-mote controls, microwaves and cars are screen-printed parts. But it's true! All circuit boards (green and copper mazes with transistors, resistors and microchips soldered all over them) are screen printed with an adhesive, and then electroplated with copper to create conductive paths. Actually, most printed copper is conductive; it's just a matter of keeping a solid line of it to keep the electricity flowing that becomes difficult on flexible surfaces. New developments in polymer-based inks saturated with conductive silver or copper will lead to wearable computers and soft circuitry. Which means that your hoodie will be a computer where you can control the temperature inside, turn up the volume of the music playing in the hood and answer calls by brushing your fingers across the wrist cuff. Those technologies all exist already! It isn't even sci-fi future! Microchips that can go through the washing machine have been invented, and they can connect to printed or embroidered circuits on your garments.

- **High-density or chunky structural inks:** There are new inks on the market that, when printed through a very thick stencil, produce three-dimensional prints. If you can imagine coating your screen until the emulsion is 1/2" (1cm) thick, then exposing a circle, and then printing it onto a tablecloth with special, extra-thick plastisol ink, you could print a plate. A real plate! Imagine the possibilities of screen printing three dimensionally: You could combine this ink with Kevlar ink or carbon fibers and print bulletproof polka dots all over your sweater. You could print thick rubber padding on the bottom of a towel and have a yoga mat. You could print your name really fat on your wall so that it would stick out like Jell-o Jigglers. You could print layer on layer of concentric squares and make a pyramid, just like the ancient Egyptians! It doubtless has many very practical applications as well...

- **Thermochromatic inks:** These inks change color if the ground they are printed on changes temperature. This means you can print on a T-shirt and when you put your hand on it, your hand changes the color of the print, a la Hypercolor. Or, if you use the inks with conductive techno-textiles (certain areas woven or embroidered with conductive fibers) you can make the thermochromatic inks change color when the conductive fibers are turned on.

 An example of this type of technology in action has been created by Maggie Orth, of International Fashion Machines. She has made color-changing tapestries using conductive weaving and thermochromatic screen printing. The military is also funding research in this field, to create color-changing camouflage. (A side note: The U.S. Army has its common fatigues printed at a very high-end handprinting mill in Massachusetts, where printers hand-pull the ink across the screens to make thousands of yards for camouflage uniforms. What luxury!)

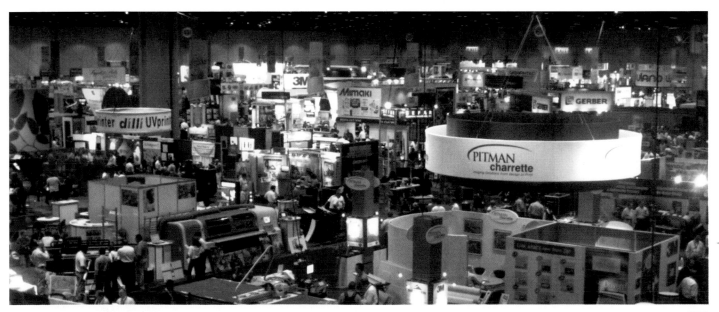

ENVIRONMENTALLY FRIENDLY MATERIALS

One thing to consider about the future of screen printing, new technologies and amazing wonderments aside, is the possibility of being less wasteful and toxic in the printing studio. There are new materials and techniques that can reduce the amount of chemicals getting near you and getting into the water and trash of your studio. Printing shops used to be really bad for you to hang out and work in, with lots of fumes, toxic volatile organic compounds and airborne crud that didn't do wonders for your longevity. Now with less toxic ink, and more attention to being responsible, we are able to make less of an impact on the environment and on our health.

The use of sustainable printing supplies, such as water-based inks, is on the rise for many applications. Water-based ink requires no toxic solvents that go into the air and water system. Closed-loop drainage systems are used for printing with less sustainable inks, such as plastisol. These systems recycle the water used to clean the ink off the screen and filter out the bad chemicals before the water goes down the drain. Some systems recycle the water back into the studio to use again to clean screens.

Now there are eco-friendly reclaimers and solvents. Soy-based ink remover, dehaze and reclaimer chemicals are odorless, biodegradable, all-natural alternatives to the more toxic chemicals commonly found in screen print studios. Other drain-safe products are on the market now, which can save you money in a big print studio by eliminating some of the special drainage plumbing that may be required to meet environmental codes in your area. Organic cotton, bamboo, soy and corn are becoming popular fibers to use for making printed apparel. Bamboo, especially, is a very renewable resource, and it takes far less energy, dirt and pesticides to grow than traditional cotton. Organic cotton, although grown without pesticides, uses an alarmingly large amount of energy to produce, several times the amount of energy used to grow the same amount of conventional cotton.

WHAT YOU CAN DO:

- Reuse materials such as tester T-shirts and papers, sponges, ink containers and rags.

- Mix up old waste inks to use as a dark color in another print or as test ink.

- Use old yogurt containers, shampoo bottles and cut-off two-liters as containers in the studio. This stuff is all around you, and it's free. Why wouldn't you use it?

- Reclaim screens and reuse them as many times as you can.

- Don't be wasteful with ink. Use what you need, and put the rest back in the container. It will save you money, and you will be personally putting less garbage down the drain and into the water.

- Try to use water-based or UV-curing inks as much as you can. Water-based inks especially have very few chemicals that break down and become carcinogenic, and because you don't have to use solvents to get them out of the screen, you don't have to mess with those chemicals and chemical reactions.

- Get biodegradable reclaiming solution that doesn't put bad chemicals down the drain and into the air.

- Use citrus-based cleaners to clean up around the studio.

- Separate things you know you can recycle from your studio trash. Just have a separate bin for papers and recyclable plastics and a waste bucket for ink that can't be salvaged. It's not that hard once you lay it out and stick to it. Just do it!

KNOWLEDGE IS POWER

Don't forget to pass on the knowledge you have. The way that we stay both connected and free is by sharing what we know with those around us. Pass on the information you learn in this book and the things you learn from experimenting with printing, papers, inks, shooting screens and getting a business started. Trade a screen-printing lesson for a piano lesson. Show someone how to print her CD cases, and maybe she'll show you how to find a shortcut in the passport renewal office. You never know what you'll get! By teaching each other what we know, we make community and we make more opportunities for everyone. If you learn from and teach those around you, it's like going to college for a billion different things for free. You have nothing to lose.

YOUR **DIY** PRINT SHOP

DIYPRINTSHOP.COM

HOME OF DIY
SCREEN PRINTING

DIYPRINTSHOP.COM

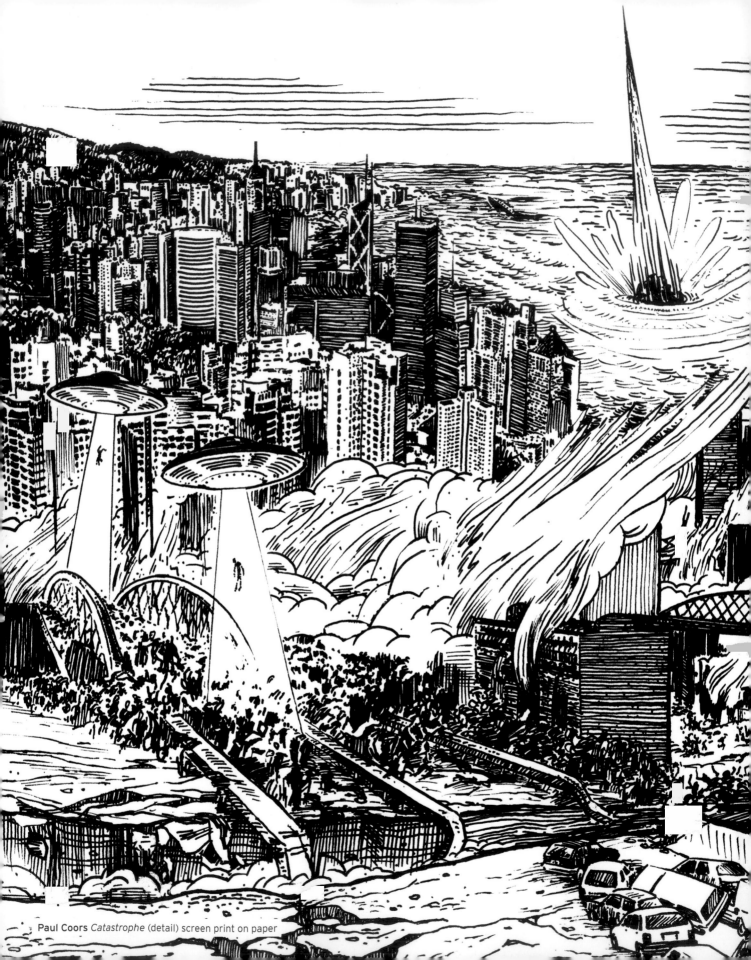

Paul Coors *Catastrophe* (detail) screen print on paper

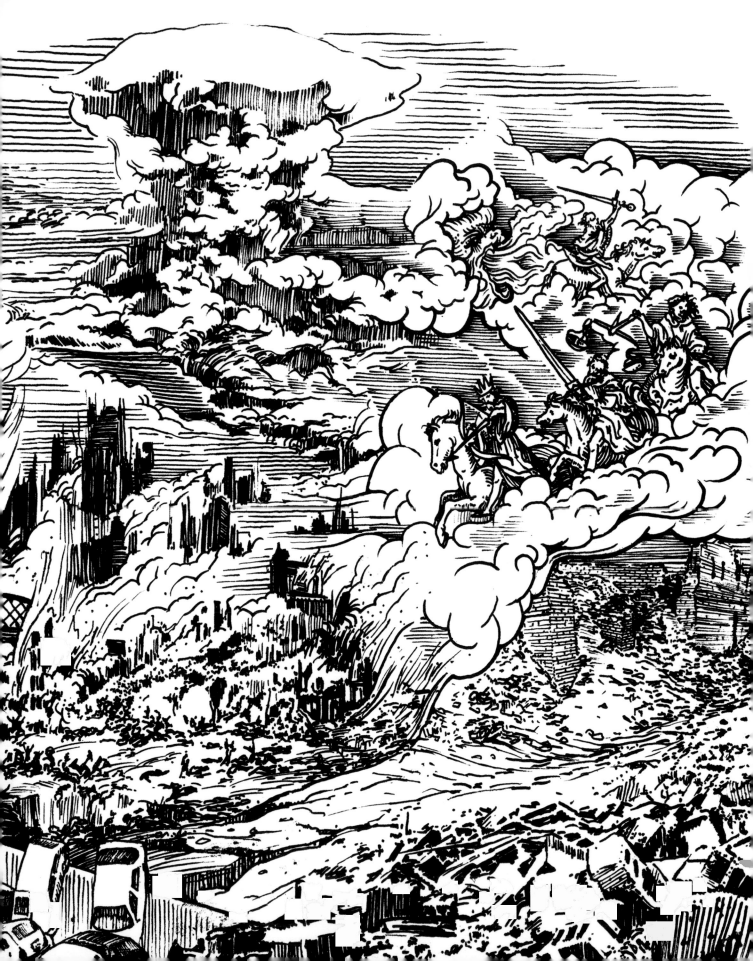

GLOSSARY

abstract expressionism - an art movement focused mainly in New York City in the 1940s and '50s that embraced creative, spontaneous action

acetate - a transparent or translucent plastic material that comes in sheets or on a roll and can be used as the clear part of a film positive (Note: Look for "prepared" acetate if you want to use liquid ink to draw directly on the acetate—it is the only type that won't cause ink to bead up.)

acetone - a solvent used to dissolve other plastics and films; used in certain direct film techniques for creating screens without photo emulsion

bridge - a "tie" to connect a floating part of a stencil to the ground around it, such as the two lines used to connect the center of an "O" to the surrounding stencil

china marker - a wax crayon with a paper cover that peels off into a cool paper streamer; creates an opaque mark good for creating a crayon-y line on a film positive

clamp light - a cheap light fixture commonly found in artists' and photographers' studios, consisting of a metal shade to refract the light and make it brighter, a bulb, a clamp to clamp it onto a bracket or shelf, and a cord; in screen printing, it can be used to make a simple exposure unit

diffraction - the process of light being spread and dispersed through interference, as with the screen mesh and exposure unit; different colors of screen mesh affect the amount of diffraction that occurs during exposure

emulsion - see photo emulsion

exposure - the amount of time light must be applied to the photosensitive photo emulsion on the screen for it to harden; also called "shooting the screen" or "burning the screen"

exposure unit - whatever situation you have created to shoot your screen—the exposure unit is basically the light source that projects ultraviolet light at your emulsified screen and hardens it

film positive - the artwork used to block light from the parts of the screen you want to print; most of the time it is a transparency with opaque black ink on it—sometimes just called the stencil, the acetate or the positive

flashing - printing two layers of ink to make the color more saturated (used mostly in T-shirt printing)

flocking - the process used to make things fuzzy; a layer of glue is printed, and then chopped-up fibers (such as silk or polyester) are sprinkled over the glue to create fake velvet

flooding - filling the screen with a layer of ink while it is raised off the substrate to keep ink from drying in the screen, done between each print

found object - anything opaque and flat used in place of a film positive

ghost - the stain of previous prints in the screen mesh after reclaiming; not a scary ghost, usually not harmful to future printing

glassine - an archival paper that feels like parchment used to separate prints in folios and flat files

gouache - opaque watercolor ink that can be used to create film positives

guillotine - a cutting tool used by book makers and print makers for precisely and efficiently cutting stacks of paper

halftone - a pattern made up of tiny dots that are bigger in darker areas of the print and smaller in others, used in printing to create gradation; you'll see these dots if you look at a picture in the newspaper with a magnifying glass

halogen work light - a hardware store buy, this light is usually used on construction jobs, but you can use it to make an exposure unit; it usually has six halogen bulbs and floods a space with light

India ink - an opaque black ink used in the creation of film positives, also used to fill rapidograph pens

ink retarder - a fluid added to ink to slow its drying, to prevent clogging of the screen; different retardants must be used for different inks

jig - a contraption fabricated to hold something to be printed in place

lithographic crayons - opaque crayons that can be used on the film positive

mesh - fabric stretched on the screen to support the photo emulsion

metal halide bulb - the type of light bulb with the most ultraviolet light, therefore the most efficient bulb to use when shooting a screen

monoprint - a print like no other, either printed with a temporary stencil or no stencil, or painted with ink in a unique way through the screen

Museum of Modern Art (MOMA) - an institution in New York City with a huge collection of contemporary art of all media

Mylar - another clear or transparent film used to make film positives (term used interchangeably with "acetate," though they are different types of plastic)

oil-based inks – inks used exclusively in screen printing for a long time; now water-based inks are used more often in their place because they are less toxic and require no solvents

opacity – ability of a medium to stop light from passing through it

palette knife – flat tool with a handle traditionally used to mix oil paints, but used in screen printing to apply photo emulsion during the pinholing process

Philadelphia Museum of Art (PMA) – an institution in Philadelphia that was one of the first to recognize screen printing as an artistic medium

photo emulsion – a photosensitive fluid applied to the screen that hardens when it comes into contact with light and becomes impermeable to ink and water

pinhole – a single hole or a group of holes in the screen mesh not filled with emulsion, appearing in the print as a dot in a place that shouldn't be printing; these holes are filled with emulsion in a process called "pinholing"

polymer – a chemical with long chains of molecules found in all plastics, including ink and photo emulsion

Pop Art – an art movement in America in the 1950s and 1960s when artists used symbols of consumer and pop culture in their works to make a critical statement about fine arts

power washer – a motor-powered water sprayer used to clean the dirt off of concrete, and to blast the photo emulsion out of a screen that's being reclaimed

rapidograph pen – a type of pen with replaceable, different-sized tips that can create lines with varying degrees of thinness; ink is added to the pen by the artist, so we can put really opaque inks in the pen and use it to make very fine lines on the film positive

reclaimer – a chemical that melts the emulsion out of the screen when no more prints are needed from the design in the screen, and a new image is desired

registration – the process of matching up positives and screens to each other when printing multiple colors

registration marks – small plus signs drawn or printed on the film positives, used to make sure the screens are matching up to each other

repeat – a unit in a repeating design that butts up to itself on two or more sides in a somewhat smooth way to create the illusion of a never-ending pattern

respirator – a breathing mask that filters out tiny particles of dangerous chemicals sometimes put in the air during reclaiming or printing with noxious inks

scoop coater – a trough-like tool used to apply thin layers of emulsion to the screen in preparation for drying and exposing it with a design

serigraph – a term once used for fine-art screen prints

social realism – a social commentary made by way of a nitty-gritty, realistic depiction of reality

solvent – a chemical used to break down another chemical

spot printing – setting down the screen to print on a specific place on a garment

squeegee – a tool with a metal or wooden handle that holds a rubber blade and is used to squish the ink through the open areas of the screen down onto whatever is being printed

stencil – a sheet of material, such as paper, metal or plastic, with parts cut out of it, used to create an image when paint or ink is applied through it

substrate – the material or surface being printed

trapping – a technique used to prevent white gaps from showing up in designs with multiple colors; the trapping area is sort of a "safety zone" where the colors overlap so that if they're a smidge off it doesn't wreck the print

T-square – a measuring tool with an attachment perpendicular to the long ruler part, used to square the straight edge at a 90-degree angle to another straight edge

UV – ultraviolet light, which hardens photo emulsion and cures some inks (UV inks)

vellum – another transparent or translucent material that can be used as the base of a film positive; may be used in place of Mylar and acetate

vinyl ink – stinky ink used to print on plastics; requires solvents to remove it from the screen

water-based ink – friendly ink used to print on just about anything; washes out of the screen with water

well space – area inside the frame of the screen free of printed design where the pool of ink sits

Works Progress Administration (WPA) – Depression-era organization created to soften the blow to broke artists by creating jobs for them in the reconstruction of the American economy; many projects, including murals, bridges and photo essays, were made as a result of this effort

RESOURCES

General Screen-Printing Supplies:
Ryonet www.silkscreeningsupplies.com
Nazdar www.nazdar.com
inks, squeegees, screens, presses etc.

DIY Screen Printing:
Your DIY Print Shop
www.diyprintshop.com
DIY screen printing kits & supplies

Packaging:
Uline Shipping Supply Specialists • www.uline.com
boxes and bags

Inks:
Lawson Screen & Digital Products • www.estore.lawsonsp.com

Union Ink • www.unionink.com

Stickers:
AllAboutStickers.com • www.allaboutstickers.com

Online Labels, Inc. • www.onlinelabels.com

123 Stickers • www.123stickers.com

Blank CDs:
Polyline LLC • www.polylinecorp.com

SuperMediaStore.com • www.supermediastore.com

CD Boxes:
Stumptown Printers • www.stumptownprinters.com

Uline Shipping Supply Specialists • www.uline.com

Paper:
French Paper • www.mrfrench.com

Pearl Fine Art Supplies • www.pearlpaint.com

Slide Registries:
White Columns • www.whitecolumns.org

Portfolio Hosting Web sites:
ArtQ • www.ARTQ.com

Artspan Contemporary Art • www.artspan.com

Gig Posters • www.gigposters.com

Wooloo • www.wooloo.org

INDEX

Look. Make. Meet.

Discover more inspiration with these North Light titles.
Visit CreateMixedMedia.com for book reviews, tutorials, podcasts and more.

Find the latest issues of Cloth Paper Scissors magazine on newsstands, or visit shop.clothpaperscissors.com!

Check out these North Light titles!
These and other fine North Light products are available from your favorite art and craft retailers, bookstore or online supplier. Visit our website at www.createmixedmedia.com for more information.

For inspiration delivered to your inbox, sign up for our FREE e-mail newsletter.

 Follow CreateMixedMedia for the latest news, free wallpapers, free demos and chances to win FREE BOOKS!

 Follow @cMixedMedia

 Follow us! CreateMixedMedia

A Great Community To Inspire You Every Day!

► Connect with your favorite mixed-media artists.

► Get the latest in journaling, collage and mixed-media instruction, tips, techniques and information.

► Be the first to get special deals on the products you need to improve your mixed-media creations.